The Making of

# New American Gospel

Drum Tablature, Short Stories,
and Reflections

Written by Chris Adler

Transcribed by Travis Orbin
and Chris Adler

ISBN: 978-0-557-68975-0

10 9 8 7 6 5 4 3 2 1

Printed in the United States

I'd like to dedicate this book to the many fans and teachers,
as well as my family and close friends.
They somehow managed to convince me after twenty years that at least a small part of my
playing is actually pretty good and people might want to check out how I go about
putting my pants on in the morning.
I hope you find this entertaining and educational.

If not, blame them.

There are several individuals that, without their contributions,
this simply would not have been possible.

Paul Waggoner

Travis Orbin

Julie Adler

Willie Adler

Randy Blythe

John Campbell

Mark Morton

Patricia Adler

Ken Adams

Brian Lemaster

Larry Mazer

Jeff Cohen

Suzanne Penley

Mike Bowen

Matt Halpern

I'd also like to thank my disgruntled neighbors and unhappy party poopers who called
to complain to my parents or the police when I rehearsed.
You helped instill in me a sense of perseverance and
a healthy sense of nonconformity.

Together with my parents' support and comically colorful responses, I learned to push every limit.
And while your complaints were not intended for this,
you certainly deserve a bit of credit in my extremely
entertaining, interesting, and fulfilling life.

# TABLE OF CONTENTS

# NEW AMERICAN GOSPEL

—probably our most difficult album to complete. So many obstacles from financial to personnel; it almost didn't happen. To a lot of people this is the beginning of Lamb of God, a "classic" piece of metal's rebirth in the new millennium. For us, on the other hand, this was as close to a disaster as we had ever come. We had just a few days to record, mix, and master it all—and very little money to get it done. We had signed a small record deal, our first, with Prosthetic records and had every intention of delivering an amazing product, but things seemed to be working against us.

Let's back up a little.

It all started in September of 1994. John, Mark, and myself decided to get together and make some noise. We rehearsed wherever we could, but it all started in the back room of my rented home on the corner of Marshall and 25th Street in Church Hill, Richmond, Virginia. For six years following, we called ourselves Burn the Priest and wrote, played, and toured as much as possible. The band did well at creating a regional fan base and a massive Internet presence just as the world of the .mp3 took off. We were there at the beginning and used the Internet in every conceivable way to share our music and get us moving. We recorded two 7" vinyl singles, released a four-song cassette, managed a few live recordings, and even covered a song called "Centipede" from the album *Pac-Man Fever* for a re-issue that never happened. In 1998, we made a handshake record deal with a kid from Philly, named Mikey Brosnan, to record and release the first, and last, Burn the Priest record. There were only 1,500 made and all of them sold within a few months. Mikey reprinted another 3,000 and they went within the year. The album itself, the work ethic of the band, and the massive Internet attention brought several larger labels to us—namely, Relapse, Nuclear Blast, Century Media, and Prosthetic. Most bands pray for a record deal and knock on every door. We just had fun, played what we loved, and seemingly all at once, in and around winter of 1999, we had everyone knocking at ours.

A little more than a year prior to all of the record company interest, the attention, responsibility, and demands for time led to several band meetings with our guitarist, Abe Spear. Outside of the band, he was making a living as a photographer. It was his job that most often got in the way of the interests of the band. We all had lousy jobs at the time that allowed us to jump in and out of town, but Abe had a real talent and dedication to his photography. It was more to him than just the means to an end while he tried to make it in a band. It seemed to me, over time, that he thought of the band as a vacation from his real job.

The meetings weren't entirely painless, and some time was put into attempting to make things work, but at the end of 1998, after a very successful matinee show at the legendary CBGB's in NYC, we split amicably with Abe. He was able to pursue his first interest, and we ours.

It didn't help Abe that my brother, a very talented guitarist, was sitting in Charlottesville, Virginia, an hour west of Richmond, doing nothing. Willie would roadie for us once in a while, but was truly, in every real sense of the famous saying, "only there for the beer." Willie had spent some time on the West coast as a cook, after mostly giving up on playing music, but he had run into some trouble and moved home to recharge. It didn't take long for me to plant the seeds and begin a collision course. Within a few weeks of Abe's departure, Willie was living with me in a bungalow behind a Richmond shopping district called Carytown, and I arranged for our guitarist, Mark, to come over and audition him for our open guitar slot. I was skeptical as I sat outside the room, hopeful that Mark would find Willie up to the job. I was basically pushing my little brother on the group of misfits we called a band. I believed he was good enough, but it had to be a hard pill to swallow for the rest of the guys. Who wants someone's little brother hanging out all the time? After twenty minutes or so Mark came out of the room with a smile and said, "Damn man, cool with me."

Willie moved his gear into our rehearsal space and the writing for a new album began. Willie played several shows with us as Burn the Priest during 1999. It became clear we had reached a new level. There was a tangible change in the capabilities and dedication of the band. We kept a rigid rehearsal schedule, most times five days a week from 5:30–10:00 p.m. We were writing furiously for a new record, as well as to replace the live material we were playing with new material that included Willie as a writer. We wanted to be ready for anything.

When the record companies' contracts arrived, they were all extremely similar, and we responded with only two simple demands:

1. Don't tell us what to write. We are 110% not interested in being artistically refocused in any manner, at any time, by anyone.

2. We are changing the name of the band to Lamb of God.

The first demand didn't shake anyone. All the labels thought we had done an impressive job working our way up through the underground music scene and didn't want to change a thing. The second, however, was a horse pill. Burn the Priest had made a very tangible name for itself in the underground scene.

10

The labels were interested in what we had built, not in rebuilding us. These demands had a few deals immediately leave the table.

People still ask "Why?" "Why change the name after so much groundwork? Why shoot yourself in the foot like that?" When we created it, we never considered future ramifications. There was no future. We were playing basements for beer and pasta. It was a scandalous name intended to spark the rebellious interest in the kids we imagined coming to our shows. Once we got them in the door, we'd blow them away and make sure they told a friend for next time. In that regard, it was perfect—and it had worked. So then, "Why?"

The real answer is two-fold. First, and most importantly, when staring down the possibility of an extended venture (dare I say, career), we had to evaluate ourselves as well as the details within the record deals. We felt that the name was purposefully based on shock value and would perpetually cloud all aspects of what our artistic and professional aspirations were. Mark was the first to hold firm on changing the name and was also the one to propose Lamb of God. The principle of this was quite an internal argument. It still comes up now and then.

Secondly, during the final meeting with Abe, he asked a question of us all. "What is Burn the Priest without me?" It may sound cocky, but it wasn't. We all felt that way. Abe was Burn the Priest as much as I was. We had all sweat, bled, and lost for Burn the Priest. Individually, we all owned it and I understood exactly what his question meant. Abe was positively instrumental in every aspect of the band. There was no Burn the Priest without him. He never actually asked us to change the name or ever said another word about it. Out of respect, this chapter had to come to a close.

Several of the record deals stuck around despite our seemingly absurd demands. They all seemed equally able to "blow the wind," and the monetary recording advances were all about the same—but the two guys from Prosthetic Records, E.J. and Dan, had what we believed would end up taking us to the next level. They flew from L.A. to Richmond to see us play a show—what might be called a "showcase"—at a local dive bar called the Hole in the Wall to a full house of maybe sixty people. The place didn't even have a P.A. It didn't matter. The label was watching and listening to the band and the reaction we elicited. They knew our reputation and considered us the lead dog in the beginning of an underground, aggressive musical movement in the US.

The label gravitated towards me for the business talk. I had been spending endless hours every day on and offline furthering the cause of the band and for most contacts I had become the go-to guy. Prosthetic talked reality, not the false record deal dreams of teenagers.

They were the smallest, newest, and most unproven of all the record companies, so it wasn't a clear-cut decision. They had good distribution set up to get our record into stores, and beyond that we all agreed that they believed in us for the right reasons and would do everything they could for the band. We signed a three-record deal with Prosthetic Records on April 1, 2000. We had continued to woodshed the material as contracts had gone back and forth and recording options were discussed.

The songs were done and they were mean as hell. Willie's arrival had the band go from a hobby to a profession very quickly. We were now, musically, the tightest and most focused we had been to this point. We had several people on the list we wanted to work with in the studio, including Alex Perialas, Billy Anderson, and Steve Austin. I, personally, spoke and negotiated with all three through the early months of 2000 and we found our partner in Steve Austin and Austin Enterprises. Steve was a well-known producer of extreme, noisy underground music and was also the main man behind the band Today is the Day. We had worked with Steve on the Burn the Priest record years prior and we all felt comfortable working with him again on the new material.

A chunk of the record advance went straight into purchasing a van that would get us to the studio, and off we went to Clinton, Massachusetts. Time quickly became an issue. It seemed there was no way to complete this album in the window that our budget had afforded us, which was seven days. We got to the studio around 11 p.m. on Friday, April 15th. Setup began immediately and recording began that night. The drums went quickly because they had to—there was no time for re-takes. We recorded to 2" tape; ProTools digital audio recording system had not yet invaded Steve's studio. We didn't use a click track, so tempos waver here and there, and there was no editing available to fix anything—"take one, hold your breath." The guitars began the next day and took a bit longer. Mark and Willie were surprised to learn a lot about what the other was playing as they sat in the control room together and tried to line things up. In the rehearsal space the amps were typically so loud that maybe they didn't hear what they thought they heard. "This is the way I've been playing it the whole time!"

Not atypical (even today), the lyrics weren't complete by the time we began recording. We had been writing them in our single, shared hotel room every day until 5 p.m. We weren't allowed to make noise in the studio until 5 p.m., as it was located in a small business strip mall occupied by normal daytime-type people. There was not a quiet room in the studio. You were in the room with the amps and drums, or you were in the room listening to the amps and drums over huge speakers.

We'd also sit in the van at night and write lyrics if one of us was tracking inside. Randy and I sat in the two front seats going back and forth for days with endless metaphors and lyrical arrangement ideas. He had the bulk mapped out when we arrived, but when the red light comes on, six out of ten songs doesn't cut it.

12

A surprise to no one, the cops came. They shut us down and almost arrested us all for being out of our minds and making too much noise one night. Our budget ran out on the small, shared hotel room and they kicked us out before the end of the recording. Willie was in art school in Richmond and had been completing semester-assigned paintings in the hotel room. When we got booted, he scrambled to get all of his materials into the van as we were "ushered" out. We spent the remaining time living in and sleeping on the floor of the studio and the van, washing in the sink in the control room. While everyone else slept, though exhausted as well, I was tormenting myself, trying to come up with the words to explain to Prosthetic that the record didn't quite work out, but that we had spent the money trying, so please . . . don't kill us? It felt as if the entire time we were just barely keeping a grasp on the notion of finishing the record, and it wasn't clear at all that we would.

The last two days of our recording window were over a weekend, so we were allowed to make noise during the day and we worked straight through. When it came time to record vocals, we had one day left. Only one day for Randy to belt out ten songs. This was quite a challenge for everyone involved. In addition to not blowing out his voice, Randy had to sing songs and arrangements he had never sung. Steve pitched in at our request, singing several bits on the record and the band worked tirelessly with Randy to find a way to make things fit. This wasn't always pleasant. It got downright aggressive at times.

Final vocals, mix, and master all in the last ten hours of our studio time.

New American Gospel was difficult to record for many reasons, but we fought the hourglass of time and budget, spending Friday, April 21 at 5pm until midnight on Sunday working non-stop. Give or take 55 hours straight. When I say we were exhausted, I mean fried. When I say fried, I mean delusional. We were SHOT. Steve included, as the engineer and producer it was his studio and his name that would end up in the production credits. Like us, he gave it his all.

We left Austin Enterprises very late, Easter night of April 23, 2000 after 'completing' New American Gospel. Accomplishment and the idea of success were not shared on the long ride home from Clinton, MA. Every one of us was completely spent, frustrated and disappointed. There was nothing more we could have done with the time we had, but it had simply not been enough. Through fierce determination on all sides we had forced the elephant into the hamster cage, but not without sacrifices, regrets and painful reminders littering the entire audio program. There was no blame game; the fact is, there was no fault to be found. No one involved could have given more or tried harder.

In the van we took turns listening to the copy of the master recording we had taken from the studio. Beyond simple tracking mistakes and a questionable instrumentation mix, the glaring audio issue was a vicious, ugly 'crackling' sound that seemed to audibly appear on every track. We frantically passed the CD around trying different devices and headphones. No reprieve. My assumption at the time was that we had made a mistake in the mastering process by slamming the mix too hard in hopes of making the CD as loud as possible. This is a typical practice, as no one wants his or her album to be quiet and we had specifically asked Steve to make it as loud as possible. Knowing that, it seemed as though the solution would be to re-master the mix and bring it back a notch or two. If this had ended up being the case, it would likely have taken an additional studio day and few hundred bucks. Not an unreasonable, or even unusual request from artists to record labels. Re-mastering happens all the time. Unfortunately, it wouldn't end up helping.

I called and awoke Steve from the van on our way home to ask if he heard what we were hearing. I heard him put the phone down, put the CD on in order to listen, skip through a few tunes, and then I heard him throw up. I don't remember if he came back to the phone. He didn't have to. The problem, officially, wasn't with our copy.

The following week, my girlfriend and I boarded an Amtrak train from Richmond to Boston, MA. Steve picked us up and we went to the studio with a plan to visit a mastering facility later in the day. We pulled up the tracks and quickly deciphered that the crackle was in the individual tracks, not simply the master. This was not good news. The tracks went to tape too hot, but no one had picked up on it in the race to get everything done. Without recording *everything* again at a lesser level, this was a problem that could not be fixed. We tried a 'de-hisser' tool but it ended up making things muddy, as if a blanket had been put over the speakers. The mastering facility took a listen and suggested a high-end version of the same 'de-hisser' product, but it left us with the same results. There was no solution; it could not be fixed. We spent the night on the floor of the studio then caught the train home the next day.

It was over.

Sometimes, when you are so intimately involved in something, it's impossible to step back far enough to understand the potential impact … to see the big picture. We had been in deep over our heads and were genuinely confused, concerned, and completely spent. None of us had a clue to the story time would eventually tell.

*New American Gospel* was finished and there was a great sense of accomplishment there, BUT:

Would the record company release it?

Would our friends and fans appreciate it?

Would we be able to look back after several years and be satisfied, regardless of success or failure?

At this point the answers to the first two questions are obvious, and the answer to the third is a resounding and very proud, yes.

# T ABS?

I've never been much of a tab guy. Aside from a few informal lessons here and there, I'm not a schooled drummer. I am, for all intents and purposes, self-taught. When I was a little kid I took piano, saxophone, tympani and acoustic guitar lessons. Nothing stuck. I took musical composition in college, but I'd constantly fall asleep. There's a bit of theory history there, but it was never my passion. Textbooks and written music don't excite me. Sitting behind the kit and finding creative solutions to the music around me is my game. So then why this, why now?

We began the Rockstar Mayhem festival tour across the US in the summer of 2010. We played an off-day show (a day that the festival takes off, but the hungry bands go play smaller markets on their own), and I was sitting in my dressing room warming up with my typical routine, when the drummer from one of the opening bands knocks and enters. We chat for a bit, and he and hands me a copy of David Garibaldi's Groove Study #1 and #2 from an instructional book he was working through and found interesting. Normally, I would have said thanks and thrown it to the side when he left, and had done so in similar situations in the past, but this time I decided to dig in.

Why?

Let's go further back.

I dedicated myself to playing drums at age twenty-one. I had played bass guitar in bands through middle and high school and would bang around on the drummers' kits at rehearsals, but it was just playing around. At a house party in high school, I was messing around on the drum kit before the band was to play, when the drummer of the band came and asked me to stop because I was playing the kick drums faster than he could and he didn't want to look bad when the band did play at the party. I suppose I knew I had a bit of a knack for it, but I was a flighty teenager who had girls and beer on the brain. I already had a bass guitar setup and I was already in a band. Why bother trying to change the script? I enjoyed it, but it took a while for me to give it my full attention.

In 1990, I began college and after a few years of having my own apartment and enough room to do so, I decided to pick up a kit of my own and bang around. Since then (1993ish), I have played drums in three bands and one small, one-song project. The first band, Cry Havoc, lasted for only about four weeks, and the second, Grouser, about a year. The third, Lamb of God, has been sixteen years and counting and certainly turned into my life's work.

In those sixteen years, the overwhelming amount of accolades for my ability and contribution to the band's sound and the rise of metal drumming in the new millennium, is humbling. It eats at me that I am, at least mentally, a fish out of water when it comes to other styles of drumming. Yes, I know every Lamb of God song, and no, they aren't easy, but if you threw me into a jazz trio, I would embarrass my deceased grandparents. Those accomplishments and awards haven't amounted to much confidence in myself as a drummer. I've always searched for learning opportunities, but always felt too intimidated to begin the process of jamming with other people or starting lessons. In my experience, drummers are always happy to share tricks and jam, but I've usually avoided those situations because of my own insecurities. I push myself and listen endlessly to music, finding inspiration in all genres, but outside of that, I don't have much focus in my personal lesson plan. Sixteen years of a very successful, full-time gig playing the drums, and I still feel like I have absolutely no idea what I am doing. I hit a point in 2006 where I felt like I was stagnating, and although I continued to push myself and build up my weaknesses, they were all defined by what I had done on the last record. Never defined by what I could do in the future with the right inspiration. Read that again, it's very important.

Additionally, my interest in these tabs stemmed from what I can best term a "repetitive mental drum injury." I never felt any pain or cramps that limited my live show, but after years and years of playing the same songs, my body started to "act up." My foot would randomly jump off the bass drum pedal, my hands would trip over themselves, and my quads would turn into mush—as if my body was trying to sabotage the show. I know the parts—damn—I wrote them, but something beyond my ageing was starting to crack the armor. The answer, I believe, was that I had programmed myself to do a certain thing a certain way. The neural pathways and muscle memory were built and off to work I went. Sounds great—until ten plus years down the line when those pathways are beaten, limp, and desperate for new stimulation. The infrastructure was showing its cracks. I needed to find ways to awaken and challenge my brain/body connection to achieve the same goal.

How did I, and how do you, go about such a thing? My entire growth on the instrument has been in Lamb of God and my general knowledge of material is primarily the Lamb of God catalog. I don't know any cover songs. I wouldn't know technique outside of metal if it knocked on my dressing room door, walked in and handed itself to me … or would I?

Like most things in life, everything is about the timing, and when my friend handed me the Groove exercises sheet, I was mentally ready to give it a shot. My creativity was stagnant and I was suffering through each show. Playing was becoming a chore and most often, a disappointment. I had to branch out to keep my passion for the drums alive—it might not even work and tabs intimidated me (sensing a self-confidence issue yet?), but what the hell … it would be different and give me a new focus.

The next few days I spent figuring out how to read the tab exercises, and the rest of the Mayhem tour I warmed up to these groove exercises. I abandoned my brutal, two-hour, drill sergeant, metronome singles and doubles torture session I put myself through every night before a show. I spent about forty-five minutes a night, working through the exercises, gradually building speed, understanding accents, and getting a feel for something very different than what I was used to. I was surprised how easy it was to understand the tabs—I don't mean easy to read and play—I just mean visually understanding what meant what on the music staff. It took quite a while for me to read and play those—and they are very basic. I'm still progressing, but what I took from those tabs and the ones I've found since, is not learning full songs or mimicking exact notation, but finding the things that are decidedly NOT what I would normally do and attempting to understand why, then mimic it. Every single time I find something like that, I can feel new pathways being built between my brain and limbs. This plays out in funny ways sometimes—I lurch awkwardly and pause at odd times while my brain convinces my arm or leg that it really IS supposed to go NOW! Old dogs learning new tricks … sometimes it's not pretty. In addition, I've been able to check out tabs while away from my drum kit and still visualize things like my hand moving from the hi-hat to an off-time accent before returning to the hi-hat—I don't need to know the whole song—I can build and create my own version of that idea just from three notes on a staff.

The time I spent working on the tab exercises seemed to give my brain a vacation from the day-to-day grind, and when I came back to the day's work, it wasn't as stale. For the first time ever, I began throwing in new fills and slightly altering parts to accommodate different ideas I was picking up in the tabs. I began to defeat frustrating moments in my playing by finding routes around the problem, not continuing to smash my head into the wall. It's worked, and it worked quickly. Playing was fun again. My live show started to become more solid almost immediately as my neural GPS was updated and rerouted. Even if it all sounded the same at 110 decibels to the audience in front of the P.A., I was walking away from far fewer disappointing shows. Walking off stage satisfied with my performance was not something that I had felt very often prior to this tour. I would always be my own worst critic and end up disappointed. When that began to change, my entire outlook improved. I was inspired to try, no longer beaten down.

I shared the exercises with several of my drum friends on the tour. We would sit in the dressing room and laugh at each other as we would lurch about at our rehearsal kits trying to read and play. It was interesting to see how other players reacted exactly the same as I had. Maybe I'm not alone with all this drum baggage and frustration, I thought to myself. Tabs aren't a secret, obviously, but maybe I could share this with more people and players just like me.

That's why.

Inspiration. Awakening new ideas. Evolving. Maintaining the passion. Tabs aren't the only way by any means, but I found a little in there and I hope you are able to as well.

If you are reading this, I don't need to try and convince you to check out tabs; you've probably already laid out a few bucks for this book. You may be a student, teacher, or just a Lamb of God drumming fan that wants to dig in a bit more. I certainly hope these tabs give you a direct insight into my playing, but more importantly that they motivate you to try something outside of your box, keep your playing fresh, and have fun with your drums.

All the best—stay metal!

Chris Adler

# New American Gospel

# Drum Setup

- **Drums** – Pearl Prestige Session Select in Black Mist
  - 12" × 10" Tom
  - 13" × 11" Tom
  - 14" × 12" Tom
  - 16"×16" Floor Tom
  - 18"×16" Floor Tom
  - 22"×18" Bass Drum (×2)
  - 12"×5.5" Mapex Birdseye Maple Black Panther Snare
- **Cymbals** – Zildjian
  - 14" New Beat Hi-Hats (Top/Bottom)
  - 14" A Custom Crash
  - 14" A Custom Crash
  - 18" A Custom Projection Crash
  - 18" A Custom Projection Crash
  - 24" A Ride (1972)
- **Drumheads** – Remo
  - Toms: Clear Pinstripe
  - Bass: Clear Powerstroke 3
  - Snare: Coated Ambassador
- **Hardware**
  - Pearl Power Shifter P201 Kick drum pedals, DW Beaters
  - Pearl Stands and Boom Arms
  - Danmar 'Metal Kick' kick Pads
  - ProMark Hickory 5A "Natural"

# Drum Key

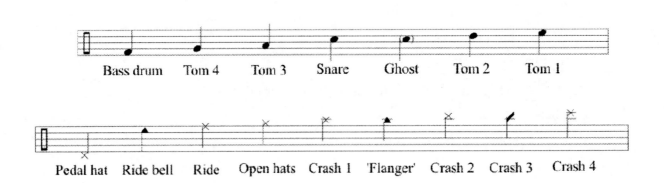

# BLACK LABEL

This may very well be the most popular Lamb of God song ever—surprising for several reasons:

1. This song wasn't complete when we arrived at the studio to record the album. Willie and I had begun writing it in the rehearsal space the day before we packed the van to drive to the studio. The rest of the guys didn't have their parts down and we didn't have an ending to the song. No one knew if we would even end up recording it.

2. The album, *New American Gospel* is our least selling album. The first week sales were 200 (compared to ~ 70,000 for our most recent record). It's obviously picked up from then, but US sales report somewhere around 125,000. That's certainly a lot, but a fraction of later album sales.

3. There are no actual lyrics[1]. There may have been a loose concept, but trust me, I was there, there were no lyrics written or read. The vocal tracking for "Black Label" was as close to bleeding a stone as I have ever seen in my life.

Eleven years after recording it, I still love this song. I fought hard for it, as the band argued about what was to appear on the record. I knew it was something special, we all did, but the way it came about hadn't left us with much time to digest it. It wasn't so much of an argument to include or not, as it was a struggle to shake off the anxiety of an unproven, un-played song starting off the album. The intro was a little bit different than what we were about at the time, but it was HEAVY and I knew it would be contagious. Normally, the songs I write with Willie are the more progressive of the Lamb of God material, but this one came out of a last-minute attempt to write a tenth song for the album. We wrote it with one day left before we hit the road for the studio. As a band, we typically we rip songs apart—the song, "Walk with Me in Hell," on the *Sacrament* record, took six *months* to write. Not this one—it just flowed and we let it—without question. We simply didn't have time.

At this stage of my drumming career, I was still very much in the headspace of "showing off." The intro was a bit dumbed down on a drum level; so much so, that I initially questioned it, but ended up letting it ride knowing that I could pick it up once the song really kicked in. I definitely did that! Kick drum runs everywhere and stop-start rhythms all over the place. I was very into cymbal grabs at the time as well, (Steve Shelton of Confessor was an influence at the time), and I tried to fit them in as often as possible.

---

[1] There may very well be lyrics to this song at this point, but they are words since drafted and lined up to sound like the noises made into the microphone while tracking the very last bit of the entire recording, the lyrics for "Black Label." To Randy's credit, he had never heard the song before being forced to scat to an arrangement that Steve and I had hastily mapped out. In addition, he had just finished tracking the other nine songs in a row with no breaks.

This song, and the album as a whole, is based on rhythmic kick/snare patterns and there's very little tom work throughout. That was my strongpoint at the time and there was no time to fool around.

"Black Label," is by far the most recognizable, and the fan favorite of the album. It could be argued that it is our most recognizable song from any album. Since its release, this song has been the last song, the encore, if you will, of every single Lamb of God live performance. Fans would riot if we didn't play it. It blew up. "Black Label" was/is bigger than the album and the band, now and then. It became an anthem on the soundtrack of the underground music scene in the US. It blew up on the web via YouTube because of an insane crowd reaction called the "wall of death" that began happening at our shows. Fans come to our shows for this alone. MTV, who continue to use it for every fight scene in their silly reality shows, picked it up as well.

It's become our calling card and created a reputation. The sound and energy is unmistakable. This song by itself—the one that almost didn't make it—helped kick-start, at times carry, and in the end deliver a career to the band.

Thanks, "Black Label!"

# Black Label

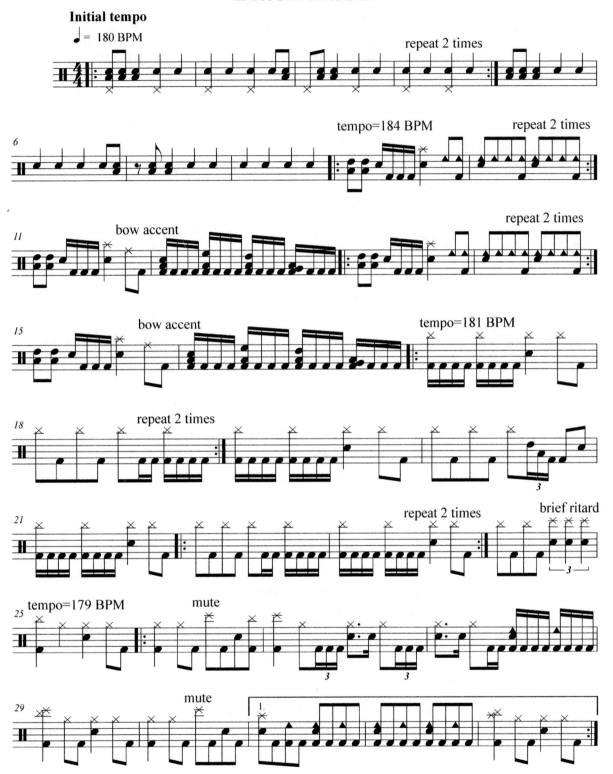

**Black Label**

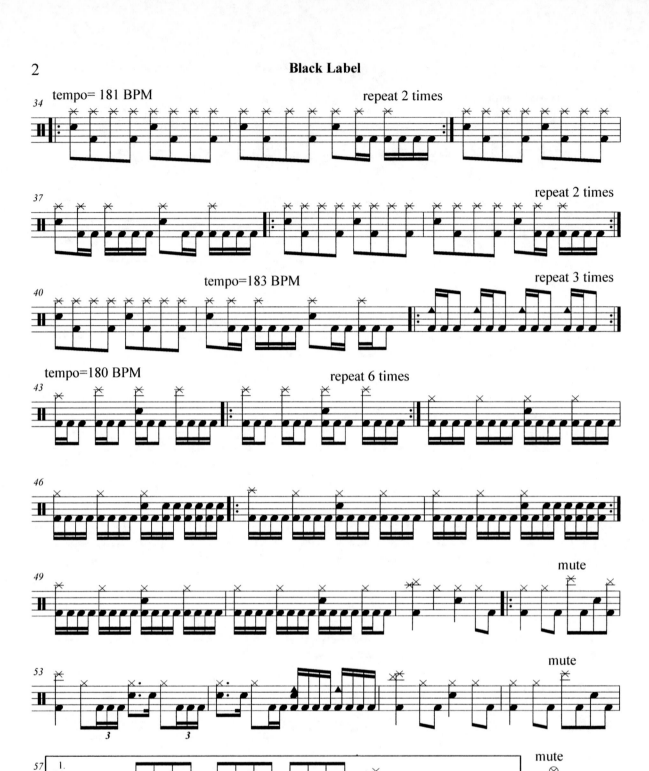

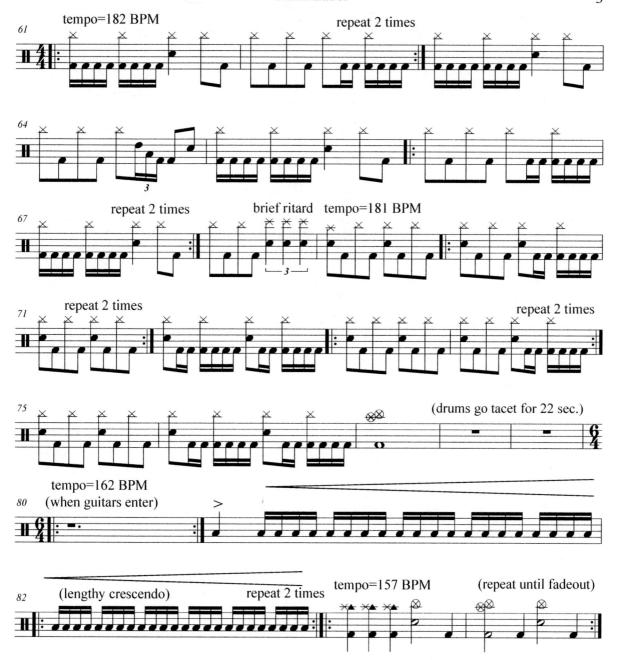

# A WARNING

This was a song we had written early in the writing process for the record. It was one of the first. Again, I was very much in the mindset of faster, harder, and heavier. The song was written absent the consideration of vocal placement and arrangement, like all of the songs except "Black Label" (ironic). We didn't care.

There are two rhythmic sections I brought into the writing process on this one. The intro pattern (0-:20) and the revolving beat starting at around 1:32 that finishes the tune. There's also a pretty fast "blast" beat starting at 1:19 (I didn't even know what a blast beat was at the time, I just knew it was fast and very hard to keep even). I didn't do those kinds of beats often, even though at the time people had been labeling us a death metal/grindcore band. I generally dislike this type of beat. I like beats that groove and make you move. Blasts are static and harsh. Admittedly, there are times that the riff or tune calls for it and this was one of them. Blazing fast death metal guitar riff—what was I supposed to do?

I'm not sure if by today's standards it would still be considered a blast beat. Things have gotten so fast with triggers and different sticking techniques, but with no triggers and no sampling, I was just going for it, all to tape. To this day when I play this part I use my left foot for the kick, my right can't keep up.[2]

Interesting note about the sequencing of the song on the album . . . Once we finished mixing, we had about fifteen minutes to decide how to sequence the album. This process can take months with internal debate and label pressure, but we had no time and no input. We all immediately agreed (except Randy) that "Black Label" should be first. The arguments then began over what would be next.

I'm not sure how I won this argument, or that I should have, but my vote was for "A Warning." My reasoning was totally flawed, but in the end it was the right call for a reason we hadn't considered. My opinion was that every big band put their best song first, worst second (to get it out of the way while the listener was still under the buzz of the first song), then patchwork the rest with the third song likely being second best. I'm not sure how I came up with this logic—if you pay attention to many successful albums and bands, their HIT is always second. Either way, the guys went with it and the song took the very important number two slot—even though in my mind it was our worst tune. In hindsight, and after seeing

---

[2] I'm left handed. I play a right-handed kit, but only because that's how the kits were set up when I sat down behind them. I never thought to move things around. People ask me all the time if made it that harder to learn—I don't think it did. It added some quirks like this, but I never questioned it. In later albums I've begun to start kick patterns with my left foot. Throughout *New American Gospel* I typically still lead right, but have a stronger left.

reviews and talking with fans of the record, it worked well second as it's probably the most aggressive song on the album. If you got through "A Warning" after hearing "Black Label," you had heard the full auditory mission statement of the band. This was the anti-HIT.

# A Warning

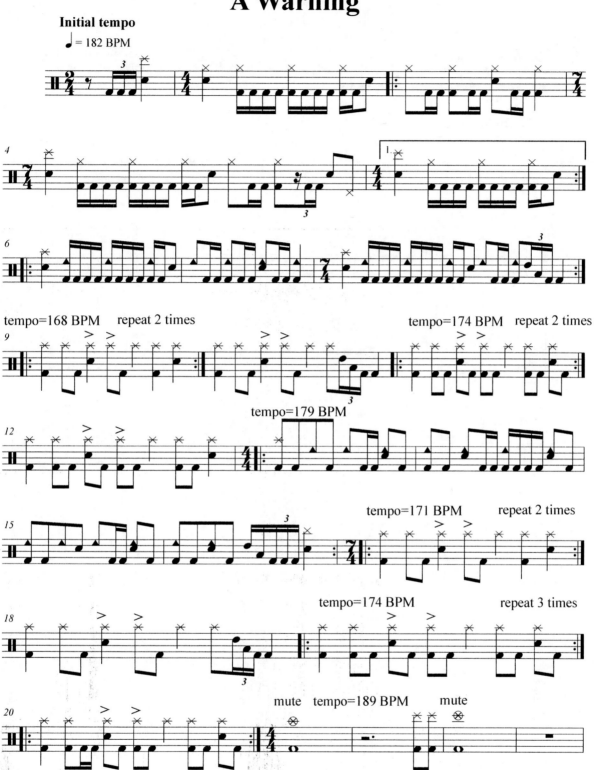

2

**A Warning**

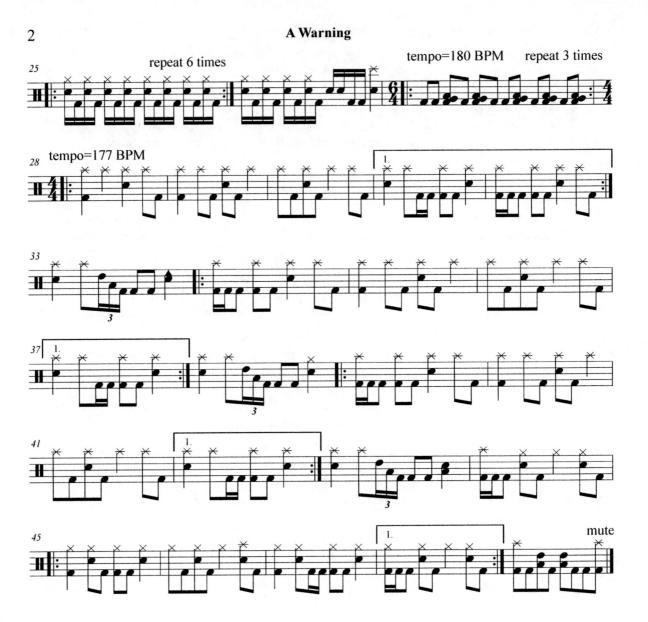

# IN THE ABSENCE OF THE SACRED

My second favorite tune on the record. This was a staple and often the opening of our live set for the next four years. A galloping intro that opens up a bit just before clamping down into a rhythmic bit brought in by yours truly.[3] The verse beat is upbeat and fairly standard (I remember wondering if it was too simple. It fit the part, but I didn't feel it was complex enough. I tried to make up for it in the chorus). The bridge drops to half time, picks back up to the same verse beat and then drops into the "chorus" (Have I mentioned we paid no attention to where vocals might go when writing the music? Here's a wonderful example. The chorus is so musically odd that there are no vocals, as Randy had no idea what to do with it). We called this bit the "Death" part as to us it sounded like something the band, Death, would have done.

Bridge. Breakdown (we didn't call them "breakdowns" at the time, but you get it—the really heavy, rhythmic part with little to no vocals. Soon every band on the planet would have fans talking about the "breakdown"). Another chance for me to throw in some kick triplets. If I was a wrestler, that would be my signature move. In case you're curious, I start on the downbeat with my left foot.

Slide smooth into a re-into, verse 2 and repeat final (vocal-less) "Death" chorus. This time the chorus riff repeats 8x. First time 6x—the pre-breakdown bridge takes up the 2 missing from the first chorus.

The outro. Sludgy guitar riff with a straight, yet off-time beat to start it out. The riff soon mutates (as per my request) leaving a slightly longer hole for me to try and confuse myself, the band members, you and every other listener. Prior to recording, I had created and memorized the order of the small drum "fills" in these larger holes (The guys in the band had no idea what I was doing–in fact, they kept losing track of when to open up the riff when we played it live. I had to queue them with the Paiste Flanger Bell when it was time to go into this bit). When we recorded it, I mixed two of them up and was distraught that we didn't have time to re-record it. Looking back now, that seems silly, but in my head at the time (and still most of the time today) there was ONE correct way to play each song.

Even though I was—and still am—the only person alive who knows I mixed them up, every time I hear it I cringe and wonder what the hell I was thinking.

---

[3] To clarify, I've never written a guitar bit for the band. I've suggested different notes and done considerable arrangement work, but when I say I brought in a rhythmic idea, I mean I came up with what I thought was a cool beat and asked the guys to mimic it with a very simple chug pattern on their guitars. They would build on it from there if we all agreed it was cool.

This song was voted out of the live set sometime during 2004 while touring on the album *Ashes of the Wake*. Around that time, I was having considerable difficulty playing some of the older tunes (songs from *New American Gospel* and *As the Palaces Burn*). Seemingly uncontrollably, I would ramp up the tempo of any part that included kick drum runs. This was increasingly frustrating and deeply depressing. It led to all kinds of additional problems and eventually the consideration of quitting the band.[4] I was very torn when this song left the set list. It had been one of our heavy-hitters for years, but I couldn't play it properly anymore. I regretfully voted it out to usher in a more recent song that I had less difficulty playing.

Years later (2008), when rehearsing for the 'Wrath' album, I played back through our entire catalog several times to keep fresh on the older tunes. I didn't remember everything perfectly, but I played all the parts, even the ones that had been driving me crazy years prior, just fine. As I mentioned in the intro, it was overuse. No diversions with an incorrect assessment of a physical issue and a forced, unforgiving routine handcuffed me to the problem and made it worse every day. As you might expect, it didn't take long to affect my psyche. It took a lot of work to turn that around and build confidence in my playing again.

Speaking from direct experience, and after years of frustration, I've learned that my drum related performance issues are indeed far more mental than physical. I refused to believe that for years and things spiraled worse and worse. Once I accepted that my focus and mental state were more important than any physical issue, things began to change for the better.

---

[4] That's a whole different book, but the stagnation and frustration mentioned in the intro are specifically what led to this. It was entirely mental, regardless of my insistence on physically challenging myself to overcome the issues. I might as well have been eating soup with a fork.

# In The Absence Of The Sacred

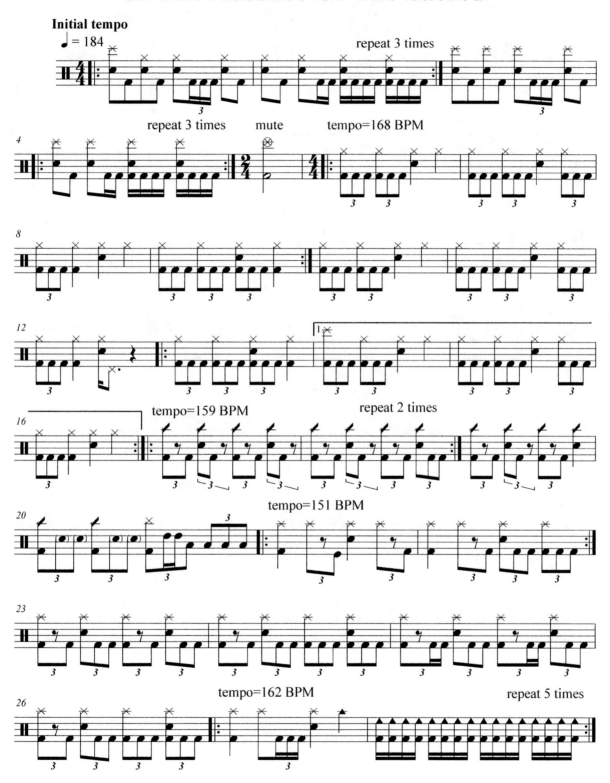

**In The Absence Of The Sacred**

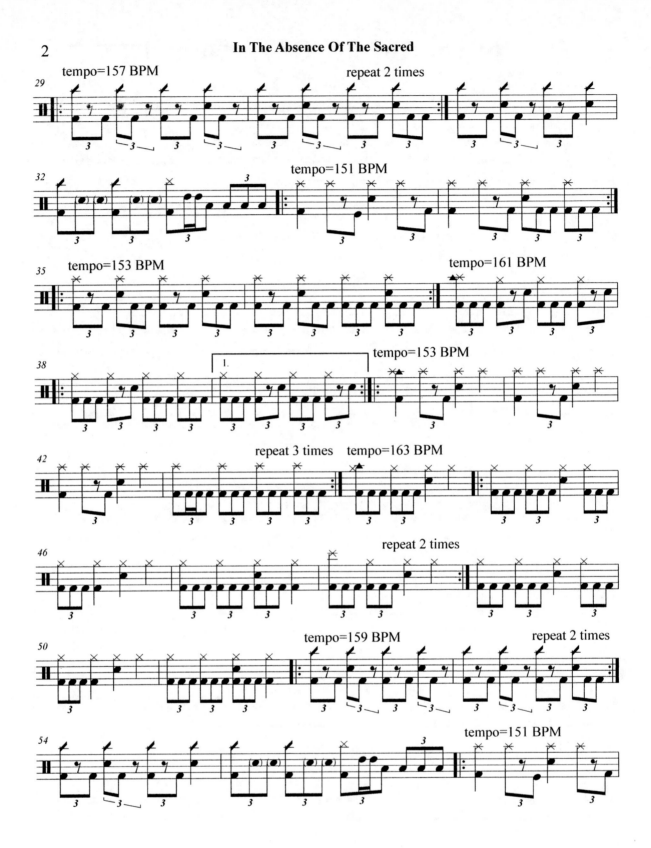

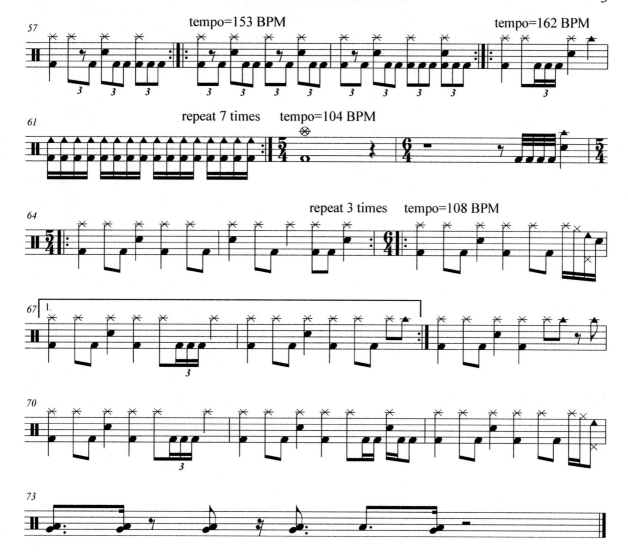

# LETTER TO THE UNBORN

Here's a good one. The working title to this song was called "5.1 Magics." It was called that because Megadeth (a band we all revered (except Randy)) had a song called 5 Magics and the intros to each bit sound similar. Except they don't. Not even close. The song the intro very slightly resembles is a Megadeth song called "Take No Prisoners." For the most part, we had our heads in some pretty funny places at the time, so this doesn't necessarily surprise me, although never having told this particular story, and fairly certain I'm still the only member of the band to realize the mislabel, I'm laughing telling it.

I was pretty proud of the drums on this tune. The intro is classic and effective. In and out, build the tension. Then I took the same beat, kept it going and moved all of the crashes but one to the ride bell. Hadn't heard anything similar, in metal anyway, at that time. This crashes and straightens out into the verse where I throw in a slew of kick triplets. The bridge picks it up before a chorus that I throw into a 6/4 feel with the kicks. Chorus outro, small bridge then a doozey of a tom roll[5] into the simple beat under the chorus.

When listening now, I can hear an issue I had when recording this song. As mentioned in the intro, there were no clicks tracks for me to follow on this record. Tempos are fairly steady, but there was nothing holding me up or down, I was just feeling it and determining, song-by-song, how they would live on the record. In the bridge and tom roll, I apparently felt the need to pick it up a bit—not a problem until I reached the second end chorus that comes out of the guitar solo. On this chorus, I wanted the kicks in 4/4 (as opposed to 6/4 in the first chorus), which purposefully would sound significantly faster. Well, it didn't only sound faster, it was much faster, faster than even I had intended. I gauge it now as straight 16ths at 200+ bpm. If you told me today to play a bit at 205 bpm, I would totally blow it. I pulled it off here, as ignorance was bliss and youth was on my side. At the time I didn't know the difference, didn't know any limits and didn't care. Without using triggers, being primarily a heel-up guy and tending to lay into my kicks a bit, if I can keep 180 steady in my playing today, I'm having a pretty good day. Even now this is the most difficult part of the US version of the album for me to recreate with my feet.

---

[5] My tom rolls at the time, were hit or miss with a good chance of miss. I had been playing for five or six years, but my focus was on my feet and rhythmic ideas with the kicks and snare. I had spent no time at all working on single stroke rolls, paradiddles, or any hand exercises. As Travis and I approached these in the tab transcriptions, he would say, "here comes another doozey!" I got a good laugh out of that, as I'm fairly certain the last time I checked, "doozey" was not a musical or drum related term.

Chorus stops abrupt into the outro. I was very proud of the tom roll that ends with the ride bell that begins this part. I thought that was a fairly unique thing to do. The beat builds with the kick drum picking up and pounding straight through. I throw in a few trade-offs with the hat and ride and a few crashes to end it out.

We were asked for years why the lyrics to "Letter to the Unborn" were not printed in the booklet. This was Randy's choice and was not due to any lack of preparation or lyrics. This was, and remains a private issue for Randy, and I don't even know the entire set of lyrics. The title of the song tells me enough.

# Letter To The Unborn

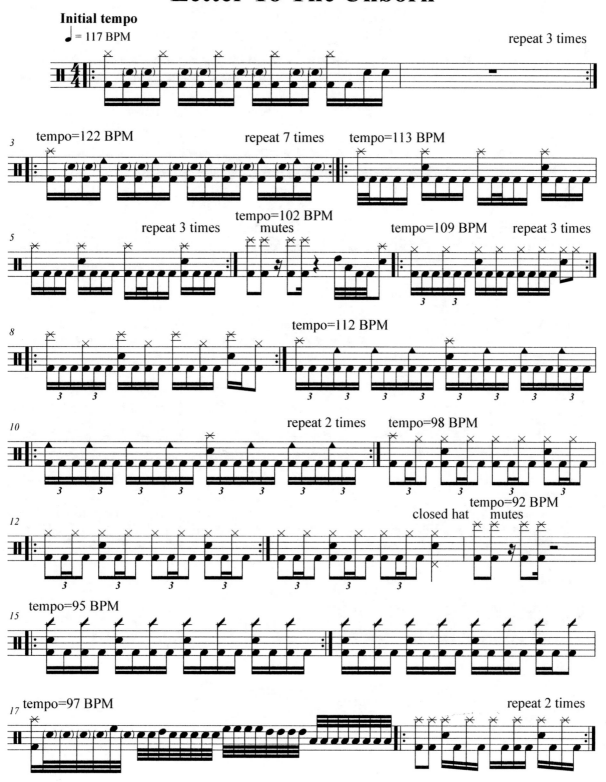

**Letter To The Unborn**

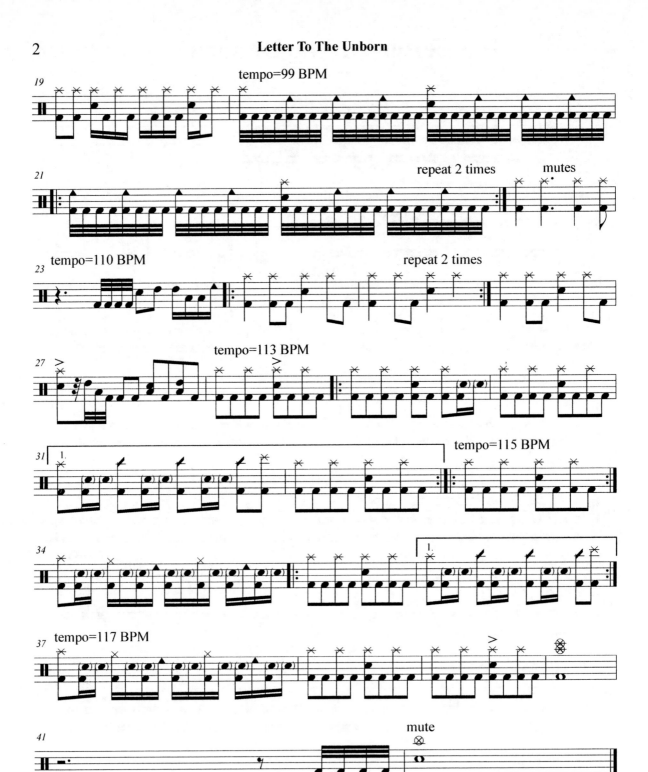

# THE BLACK DAHLIA

This was the first song we wrote after bringing my brother, Willie, into the band. The working title was "New Willenium," for obvious reasons. I love the kick drum triplets through the intro. As previously noted, I played bass guitar through high school and college and learned that in metal guitar the triplet is king. I brought that mindset and experience with other instruments to the drums, often adding triplets and having the guys follow. The experience in a band outside of playing drums also helped me communicate within the band. I understood the headspace of the guitarists and caught on quickly to ideas they tried to communicate through their instruments. I had been there. Often I would mimic the guitar picking patterns with the kick drums, or create kick drum patterns that I knew could be replicated with a pick on the guitar. This was the case here, as we locked together quickly on the triplets throughout the intro.

The intro breaks into a bridge before the first verse. This bridge has some pretty speedy kick work. It begins around :42 and even today I use my left foot to do the singles before each singles kick drum run before the extended run begins. My right foot could never keep up as well. The verse is pretty straightforward with a few quick tom hits and cymbal accents that repeat the pattern. This breaks into a quick kick run with intermittent high hat triplets thrown in to match the guitar riff turn around. The drums break under the same guitar riff, building back up using the frequency of the snare leading towards the ever-important "breakdown." This was a rhythm I had brought in and worked on with Willie until it made some sense. I was really intrigued by the extended phrasing I was starting to hear coming out of Sweden, as well as the jazz/fusion-based instrumental metal I was listening to at the time. This part was my best attempt to come up with something that didn't repeat after four. I improved at this concept on later records, but this rhythm is interesting and doesn't distract from the heaviness. That balance is difficult for many reasons. You have to consider, and sometimes keep in check, your ability, ego, and your audience. Too far down the progressive path and you're writing music only musicians can listen to and appreciate, too far the other way and it becomes too dumbed down to grab anyone's attention.

There is no right or wrong in this formula. You have to come up with that on your own, based on what's best for the song and the audience you hope to interest. All of that said, I'm speaking out of hindsight and experience since at the time we did this, I wasn't consciously considering any of that. We just happened to musically navigate between the extremes.

The song repeats the bridge from the beginning and ends with the same run—except you can hear me stop the run just a little bit early to position my feet correctly for the triplet that ends the song. This was not

musically intentional and I never even realized it until Travis and I heard it doing the tab transcription. It was an interesting find considering that my body was making the two parts capable of physically meshing by unconsciously changing something my brain intended to have in place.

Here is an interesting note about the intro of this song. Our friend Ian had recorded all of our demos at our rehearsal spot and he was asked to come up with some interesting segues for the tunes. We didn't want movie samples or anything like that, nor did we want music. "Some kind of industrial noise" was what I asked for. This shows up in several places on the record. One such place is the intro to this song.

We added the screaming. Well, I did. That's me, curled up in a ball on the floor of the studio, screaming into a mic. The guys and the producer could see by day four that I was about to have a nervous breakdown about how behind we were, how out of money we were, dealing with the label and the general pressure of making our first record be as good as it could be. He handed me a mic, closed me in a room by myself, and told me to let it out. I did. We distorted the scream and pitched it so it was hard to tell what it was, but now you know.

# Black Dahlia

**Black Dahlia**

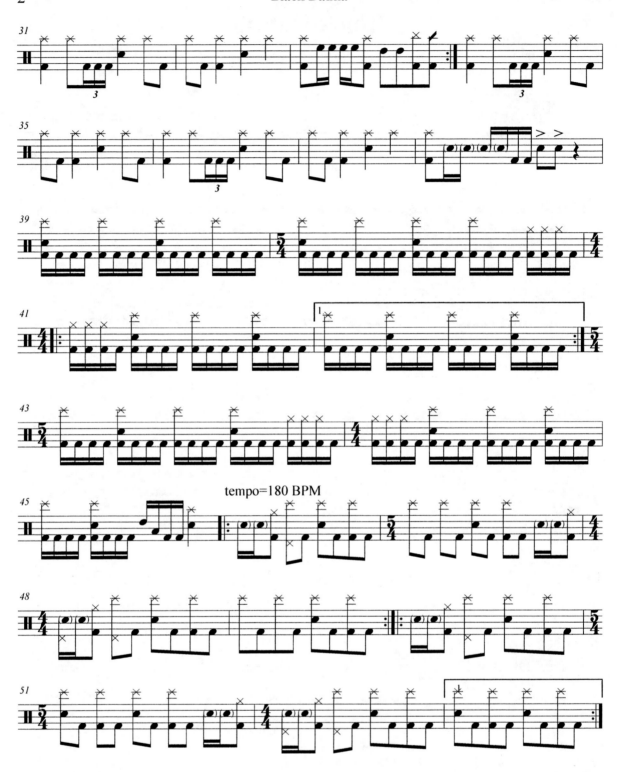

tempo=180 BPM

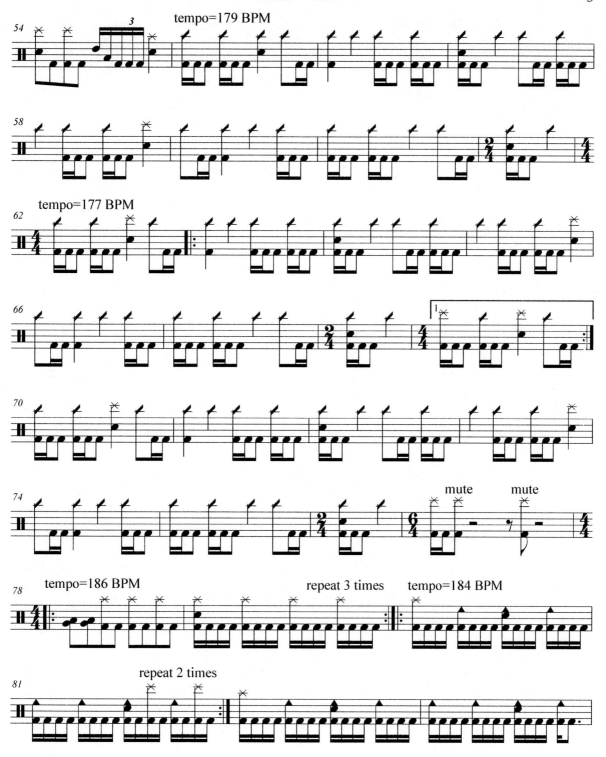

**Black Dahlia**

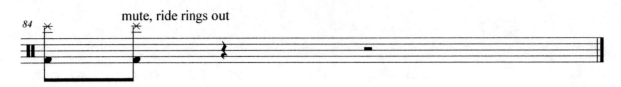

# TERROR AND HUBRIS IN THE HOUSE OF FRANK POLLARD

Let's just get it out of the way. Frank Pollard was a buddy of Randy's in or around Chicago who collected stuff in jars in his house. Weird stuff. The kind of stuff you have to keep in certain kinds of fluid. Let's leave it at that.

Similar to song 10, "O.D.H.G.A.B.F.E.," this tune starts with a slow, heavy, droning intro meant to build anticipation for what is to come. Nothing tricky on the drums through the intro, just caveman bashing. I'm happy to dumb down a part in the name of heaviness as long as I know the next bit, or somewhere not too far removed, is going to really pick up on the drums. Great example here, the intro is about as sparse and simple as I've ever played because I know it's going to explode afterwards.[6]

Since we didn't have a click track for the guys to guide them after my recording, you can hear me lightly tapping the stick clicks for their timing cues if you listen carefully enough. Verse 1a begins with several quick stab kick/crash mutes and breaks into beat with several runs of six kicks within and a ride bell keeping time. Verse 1b has the beat pick up double time, the six kicks runs picking up frequency and the ride moving over to the hat. I flip the beat and simplify it for the bridge leading to the chorus.

This chorus was one of my favorite parts of the album as it was my first time intentionally using ghost notes on the snare.[7] Musically the bottom drops out with sparse kicks and bass guitar under the snare and highest crash cymbal. Two long repeats and the quick kick drum run of 16ths begins under the snare pattern for the same length. This spills into verse 2 where I abandon the kick runs of six and just bash away with a very straight beat. Often when we played this song live, I would continue the kick drum 16ths run from the chorus straight through Verse 2a and have it cut time and sound even heavier dropping into Verse 2b.

---

[6] This concept is how I justified to myself underplaying a part. In the end though, I think it has the same impact on the listener, providing a calm before the storm and having the more complex beats stand out even more. Sometimes, less is more.

[7] If you notice them earlier or later—they weren't intentional. They weren't necessarily a mistake either. Sometimes you don't even realize some of the little things happening when everything is always 100 mph. I'd often let my right hand drag on the snare after each hit and depending on how the rest of my body was moving/dancing to the parts, it could easily create unintended notes.

Verse 2b cuts time and sets up Chorus 2, which begins this time straight away with the quick kick run established in Chorus 1. After only two repeats this time, we drop back into a repeat of Verse 1a. Verse 1b repeats on schedule and then into the bridge. This leads to the epically heavy outro that is based on a sped up version of the intro.[8]

We repeat the pattern four times while the haunting lead line hovers above. The guitars tighten up into a chug pattern and the drums pick up the beat into an outro verse to finish up the tune. Steve (Austin) sings the intro to the song and makes another vocal appearance here, singing, "I'm sailing," repeatedly. I've never been much of a stickler for lyrics, in fact I've learned to completely block out most metal vocals entirely, but this line certainly struck me as odd. All I could think of while watching and listening to Steve sing, was the Christopher Cross song, "Sailing." I mentioned to everyone that I thought that while it sounded good, I couldn't imagine any possible relevance to Randy's lyrical concept, even though at the time I had no idea what that was. It was a tough choice to even raise the issue due to the extremely limited time we had remaining. Everyone was happy with Steve's vocal performance and we NEEDED to move on. Randy assured me that the line fit right in and I dropped it. Much later, when I read the rest of the lyrics for the song, I realized that this line made just as much sense as any of the other lyrics.

We kept this song in the set until the *Sacrament* album was released in 2006, and most times when we were in the New England area, Steve would come out and sing it with us. By then though, when we did play it, people would stare in wonder as to what song it was. The *Sacrament* album marked a huge change in the size and expectations of the bulk of our audience. After hearing repeatedly that this song and "The Subtle Arts of Murder and Persuasion" are favorites of our purist fans, I hope that we are able to bring them back in to future set lists, as time permits.

---

[8] We didn't have it all together on this record, but we did have the wherewithal to foreshadow musical ideas and find unique ways to return to established passages throughout the tunes.

# Terror & Hubris In The House Of Frank Pollard

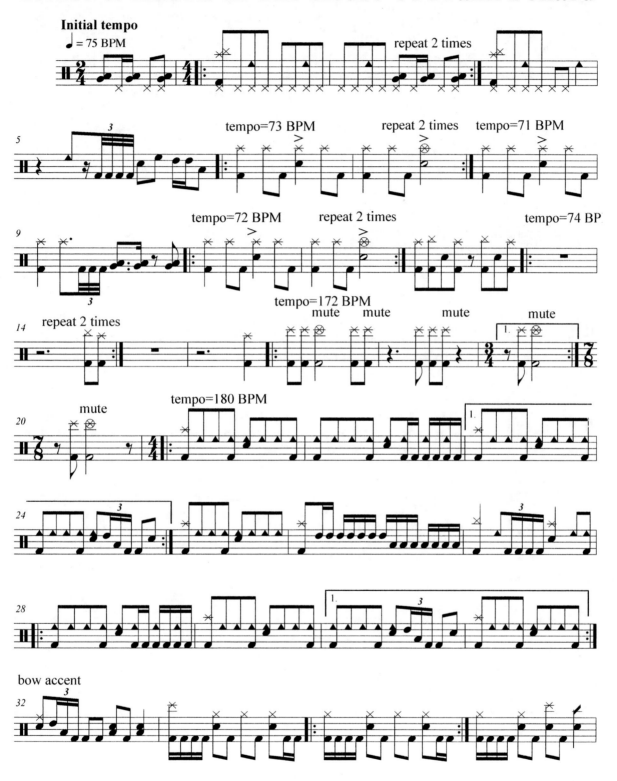

**Terror & Hubris In The House Of Frank Pollard**

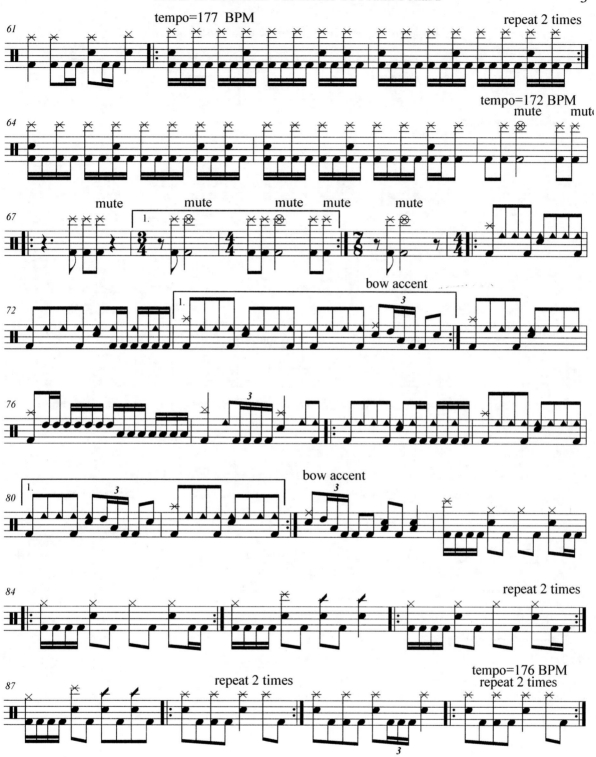

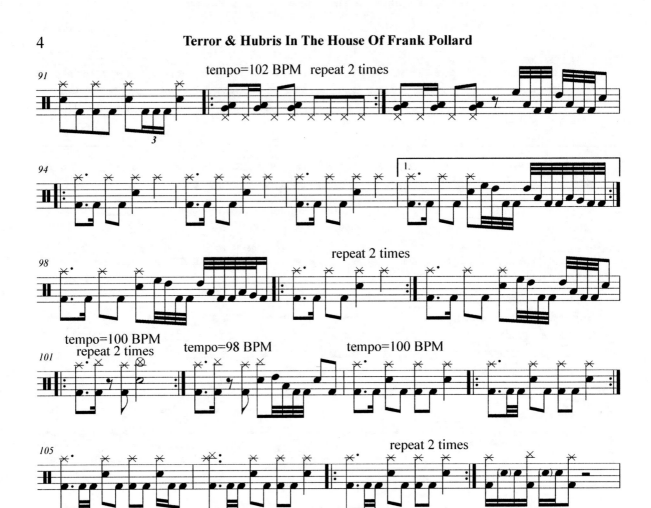

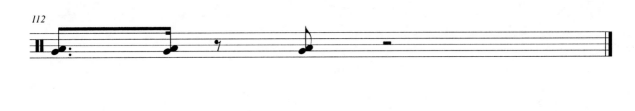

Photos

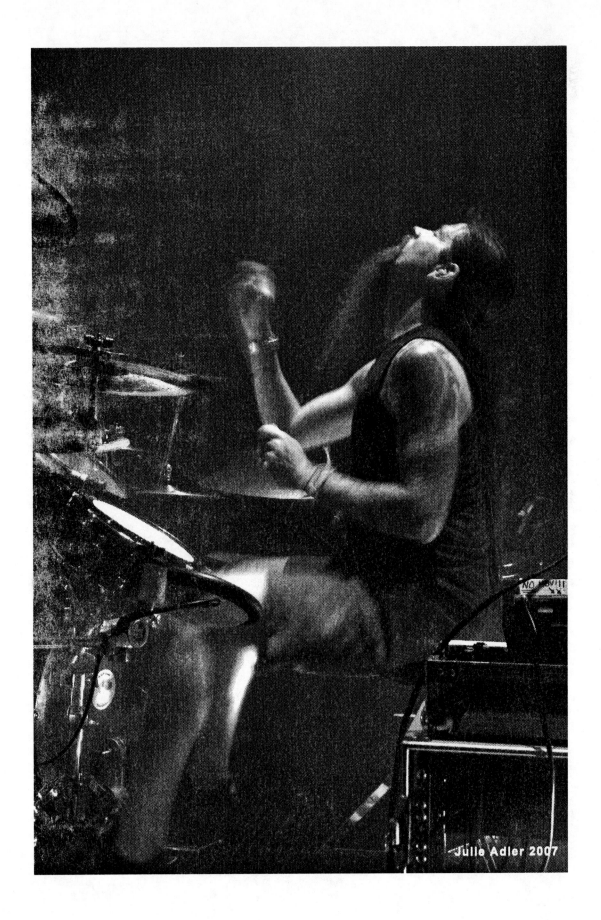

Julie Adler 2007

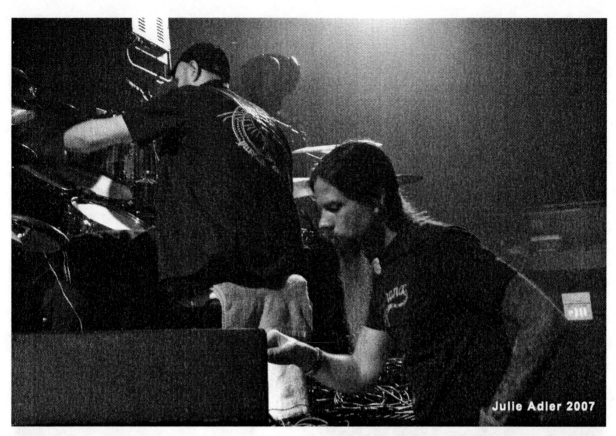
Julie Adler 2007

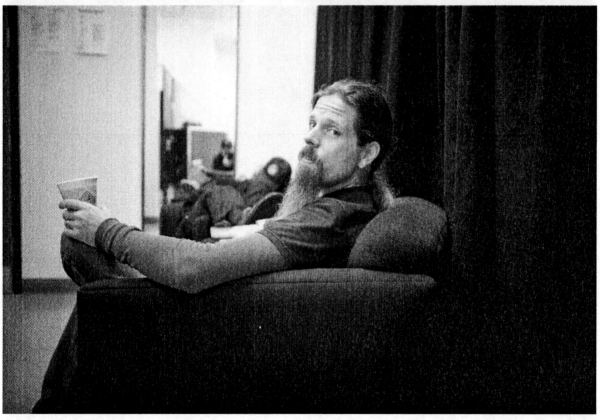

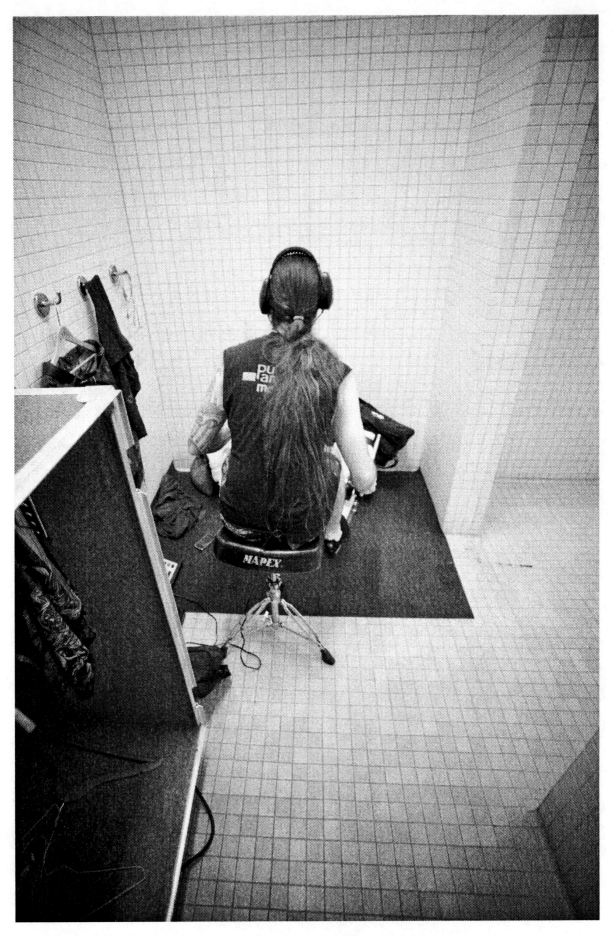

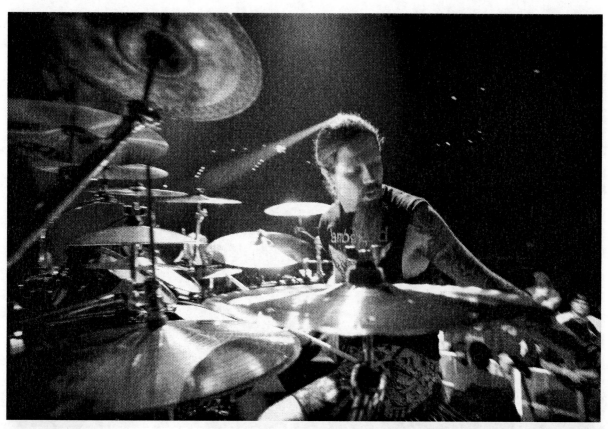

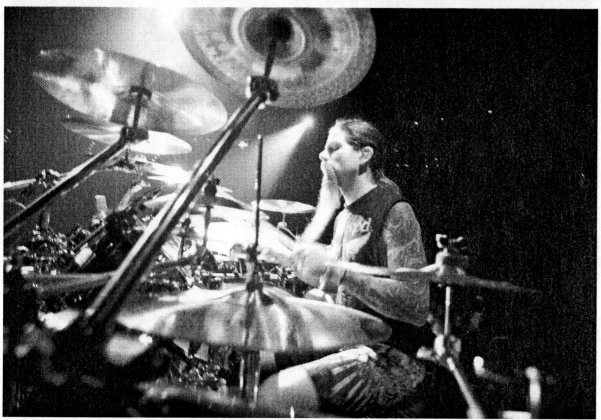

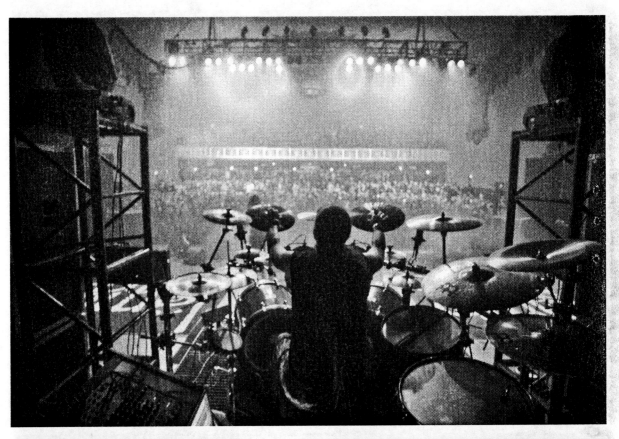

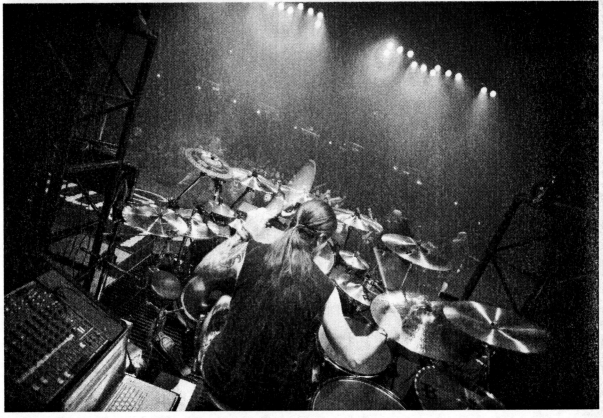

Julie Adler 2007

Julie Adler 2007

Julie Adler 2007

63

Julie Adler 2007

Julie Adler 2007

Julie Adler 2007

Julie Adler 2007

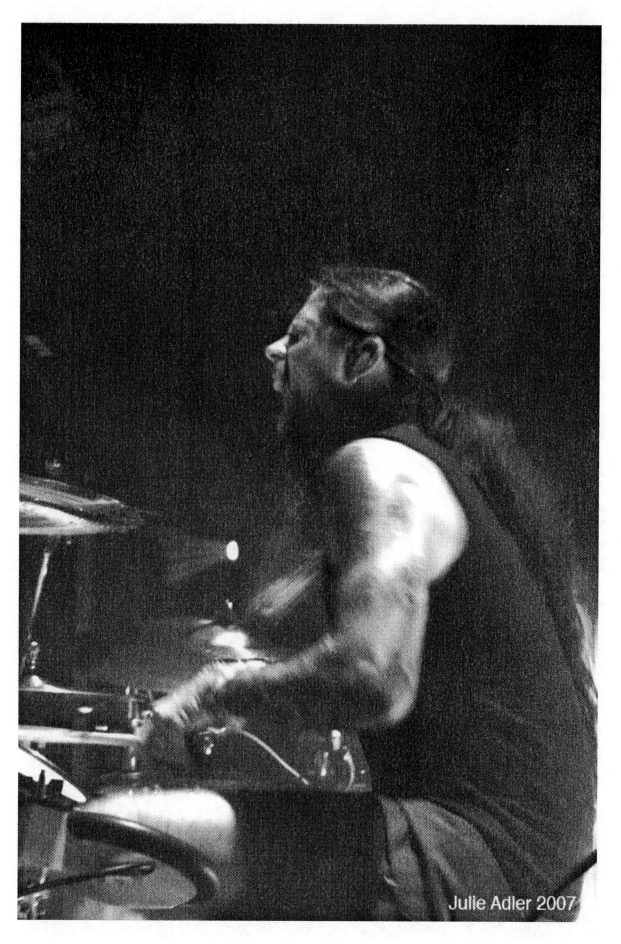

Julie Adler 2007

Julie Adler 2007

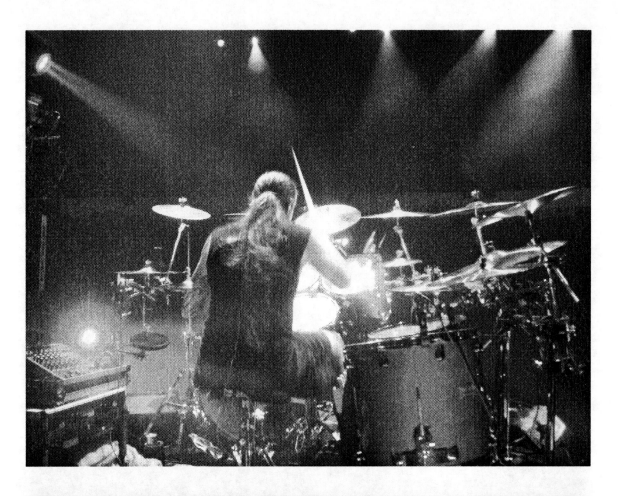

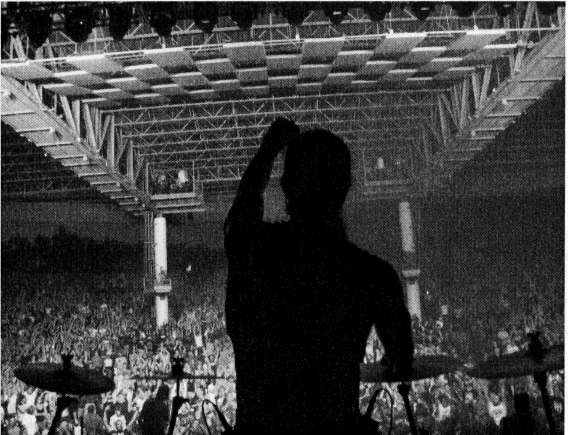

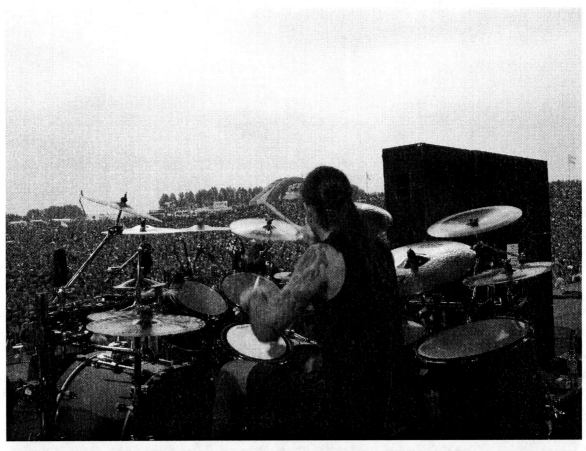

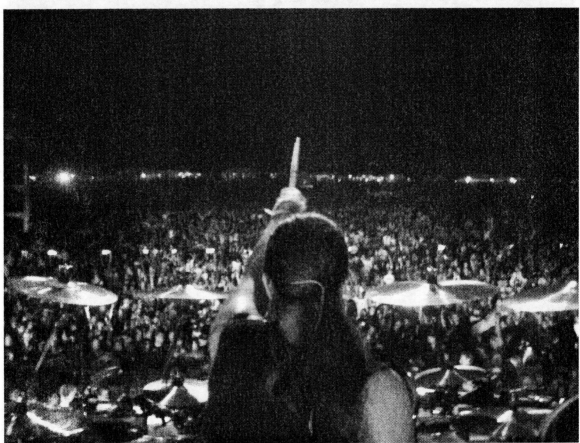

# THE SUBTLE ARTS OF MURDER AND PERSUASION

A mainstay of our live set for eight years after the release of the record. It even made an appearance on our Euro 2010 tour. This song and "Black Label" were the two songs that connected best live and kept *New American Gospel* alive at our shows. Interesting how this song and "Black Label" have a similar "pulse" rhythm through the intro. It shows how important that kind of build can be in how a song connects with listeners.

Drums break into a simple heavy beat while the guitars stay the course until we all convene on the opening pulse rhythm at about :54. Guitars maintain that pulse rhythm now and the drums break into a beat as the vocals begin. In analyzing it, it's interesting to see how we (myself and guitarists) trade back and forth on holding down the rhythm or syncopating. There is an eight bar repeat here again with a snare/crash placement being the only difference. This breaks to a guitar build and what I'll call the first verse. Simple and heavy was the goal here. I didn't want to take away from the guitar riff by overplaying. The next part, I'll call the chorus, has the drums pick up double-time to offer a boost coming out of the verse, then drop back, alternating back and forth giving a push-pull feel to the entire part.

Out of the chorus, drums and all rhythm guitars mute here and allow the haunting lead line to take the front seat. Several stop/starts hint at the aggressive rhythm ahead. This is where the song, for me, gets really good. I'm always a sucker for mid-tempo double kick, but the feel of this part really grooves.[9] This ends with a tom roll that breaks the feel and time. The drums straighten out and I move to ride accents that dance around the guitar line. I follow the guitar riff that ends this part with a series of quick kick/snare/snare combos that straighten out after four to kick/snare. By the time it straightens out, it's moving pretty quick and this was always a struggle to get lined up when we played live. We didn't use click tracks and didn't have in-ear monitors, so if any one of us fell off the tracks here, it was a total bust. We never stopped the song, but I certainly remember a few mushy evenings.

The outro is all about heavy. Nothing "techy" here until the very end. Once again, cave man drums. If you listen closely you can hear some ghost notes on what sounds like the snare as this part kicks in. They aren't

---

[9] I'm well aware that I'm asking for it by saying that any of this music "grooves." However, in context, I think we are one of the more groove-oriented metal bands around. Given the option I'd always choose a beat that would make you move, jump, dance, or headbang over something static, technically impressive or self-indulgent.

really. I blew the triplet drum intro to the outro when we tracked this, so I punched in the end of the song.[10] The *ghost* notes heard are recording bleed from my first, blown attempt. The drum tracks were re-recorded for these seven seconds, but the original tracks remained slightly audible on the tape under the new take.

The song finishes up with a kick drum run, the snare accenting the guitar rhythm. I straighten this out, giving the end a sense of speed, and end with a long tom roll and cymbal mutes. My playing style has changed so much since this record, that today I have a very difficult time jumping into the kick run that ends this song. It's not that it's too fast; it's just plain uncomfortable. It seems foreign, like someone else wrote it. Granted it was eleven, maybe twelve years ago now. It's not something I would write the same way today. I've come up with several ways to slightly alter the beat leading up to it to get my feet moving and in place. For years, I wouldn't allow myself to do such a thing. It had to be exactly what was on the record or it was wrong. Maybe it's age, maybe it's rationality setting in, but at this point I figure that since I wrote it, I can do whatever I feel like with it. I've evolved, it evolves.

---

[10] Punching in is a recording method used to recapture a bit that wasn't quite right as opposed to re-tracking (re-recording) the entire song.

# Subtle Arts Of Murder & Persuasion

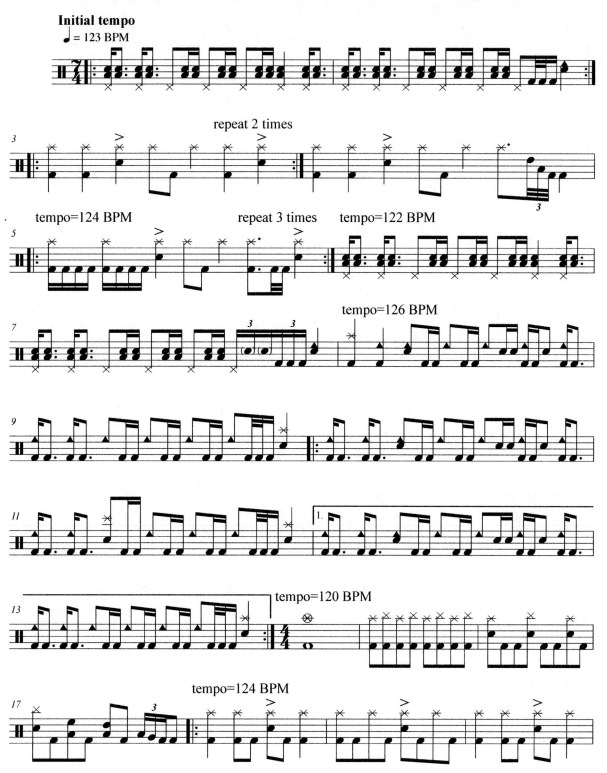

**Subtle Arts Of Murder & Persuasion**

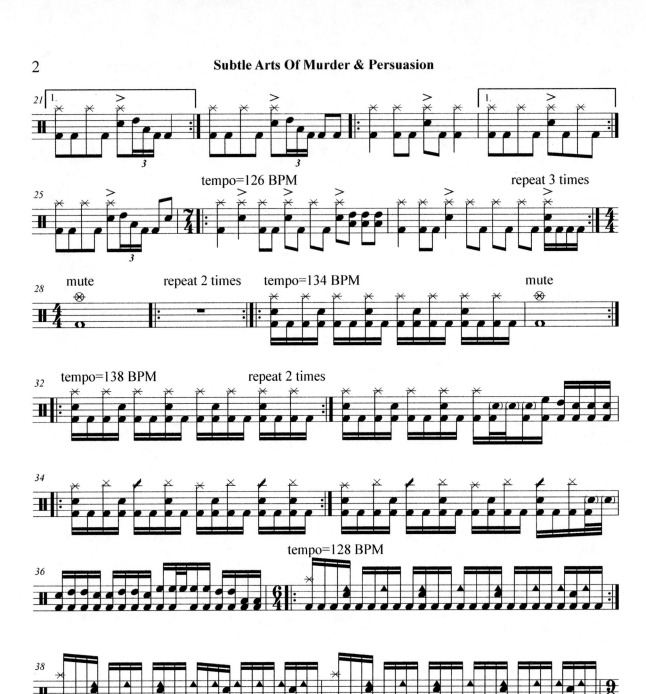

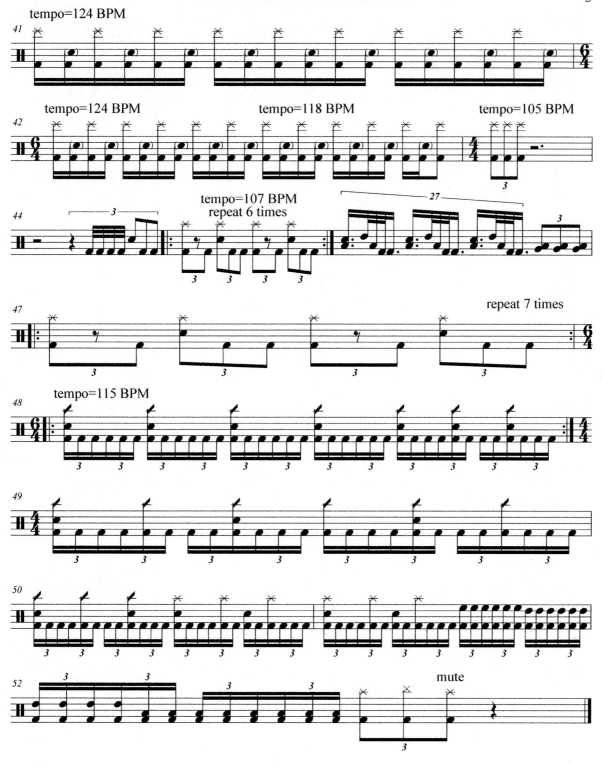

# PARIAH

Our buddy, Ian, is back at it with the intro. I seem to remember him telling me that this was the sound from an elevator shaft that he had altered into this hyper-industrial noise. I thought that was pretty great. This was my favorite piece he brought into the process. It fit perfectly onto the kick triplet drum intro of this song.

This song caught the attention of professional skate boarder, Danny Way, who was playing a big role in building up the DC Shoes Company in Southern California. Timing and luck again—the song was used in a national commercial for DC Shoes where Danny was dropped from a helicopter onto a skate ramp, and in some of Danny's other DVD footage as well. This got us "in" with the SoCal skate scene and helped boost the bands popularity on the West coast of the US.

Back to the drums! Triplets. Have I mentioned that I like triplets and triplet-feel? So the intro is a series of tight triplets that the guitars lock into until I straighten the beat with a kick drum run and the guitars open up the riff. Abrupt stop and build to the verse. The verse, like in many of the previous songs, is all about heavy. No tricky business. This verse transitions to a verse b, or bridge, that brings back the triplets and kick drum run reminiscent of the intro before breaking into the musical[11] "chorus." The chorus keeps the triplets coming with the rhythm section locked in with a dissonant haunting lead line laid over top.

We then head into what most would probably call a breakdown. A tight rhythmic pattern devoid of melody. I'm a big fan of this blunt musical style. It's all over this record. I would bring in beats and ask the guys to lock into the pattern, sometimes it built from there and sometimes it stayed locked down. Most of the time, if it did build it would be the guitars adding layers, but here, it's me adding a bit of back and forth under the pattern until a lead guitar line begins and we transition back to the pre-chorus bridge. This is the same as the first bridge except that during the kick drum run I double time the snare and the ride cymbal.

"Pariah" ends with a chorus (this time with lyrics???) musically the same as the first go around. This song, next to "Black Label," stood out. The DC Shoes TV commercial that played on MTV and VH1 had us in the ears of many more music fans than we could have done on our own. We still do not get any national radio play, so this was HUGE. I've heard from many fans that this was how they originally found us. In addition, it also landed us one of our very first sponsorships (even prior to musical gear) with DC Shoes.

---

[11] It makes sense, to me, musically, that this is the chorus. Why there are no vocals on the 1st "chorus" is a very good question. Randy was never around when we wrote the tunes. The band helped create and heard many of the lyrics and lyrical arrangements for this album for the very first time during the recording process.

# Pariah

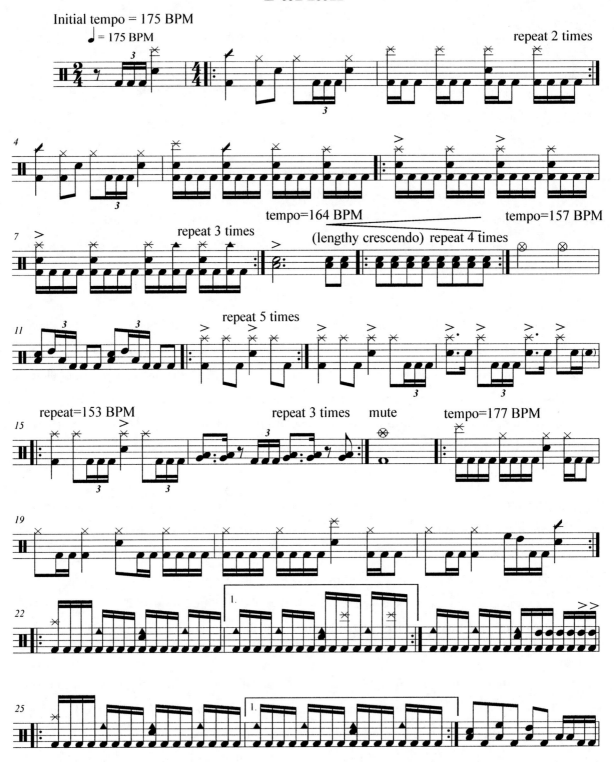

**Pariah**

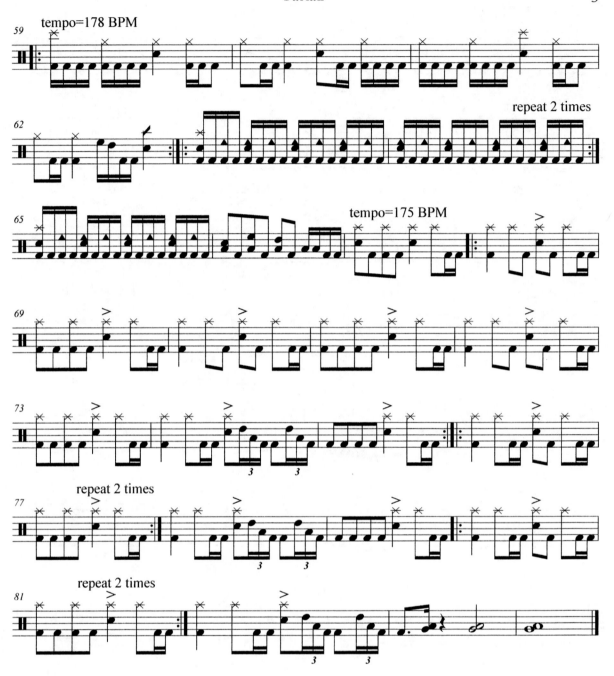

# LOVE AND THE POCKET MONKEY (CONFESSIONAL)

Finally, a song that begins properly—drums only! The working title for this song was "Pocket Monkey." All of our songs had working titles since there were no lyrics during the musical composition. A few examples include:

1.   "Flux" turned into "Pariah"

2.   "Half-Lid" turned into "A Warning"

3.   "New Willenium" turned into "The Black Dahlia"

4.   "5.1 Magics" turned in "Letter to the Unborn"

5.   "Pocket Monkey" turned into "Confessional"

In this case, "Confessional" got the working name "Pocket Monkey" in an unusual way. My wife (girlfriend at the time), was into sock monkeys and one day around this time, I bought her a key chain sized sock monkey I saw on sale somewhere. When I got home I pulled it out of my pocket to give her. She called it her "pocket monkey." Later, when she and I were listening to our rehearsal space demos together, she would ask what the songs were called for purposes of discussion or comment. I'd tell her the working titles, but we really didn't have or need one for this particular tune since I started it and there was plenty of time for the guitarists to figure out what song it was during the extended drum intro. She enjoyed this tune a lot, more so than the others, or at least acted like she did (it starts with drums and she's a very supportive lady). She and I talked a lot about our songs and somehow she bequeathed this one "Pocket Monkey." I brought that name into the rehearsal room. None of the other working titles made any real sense so it was as good as anything else. The guys unanimously thought that it was totally lame and ended up calling the song something else amongst themselves. They never called it "Pocket Monkey," but since I started the song, I'd call it out before starting it up. They'd all give me a look.

If I were to put this song on today and ask my wife what it was called, I guarantee that she would say "Pocket Monkey."

In the end I kept it. For us, I guess. Love … Great story, huh?[12]

---

[12] No, I cannot refund those 30 seconds of your life.

So we start off with a repeated pattern for the intro. I brought in this tom heavy pattern and the guys built the riff on top. Nothing too complicated, but it goes on for a while as the riff builds and crashes in. When we played this live, the guys would extend the feedback bit here before starting the riff—maybe to build more tension, maybe to take a bit of a break for themselves, but I remember on more than one occasion yelling at them to start the damn thing because I was quickly running out of gas!

After four runs of the full riff, the pattern breaks to a kick/snare/hat beat that accelerates (remember, no click tracks) for four, then the 16ths on the kicks come in to fully beef up the part before it drops half time into the verse. The verse repeats nine times with the 5th cutting the beat in half and serving to split the 2, 4 bar sections. I added this in hopes of keeping the seemingly long, eight bar (originally) verse, interesting. Quick mute at the end of the 9th bar, then all hell breaks loose.

The guitars then go into the most black/death metal riff we have ever written and I'm not sure where this came from since none of us were listening to death or black metal at the time. It's there because it's fast and that was the goal for this particular break. The beat is brutal. Not since the recording, have I played this part as well as I did this day. It's not the fastest beat ever, but it's the fastest beat I've ever played without kicks under the snare hits. This is blazing fast for me. I'm surprised that it holds up in volume—there were no triggers or studio magic here, this was run and gun recording to tape. I was hitting hard, and fast. The tricky part is the two kicks between each snare—one is probably not as difficult, but two make it pretty tough, at least for me. If you can pull this bit off clean, you got skills. The beat breaks into a run of kicks with the snare/crash accenting the riff. Three quick mutes, a sweet single stroke tom roll down the toms and repeat verse 1.

I brought in the rhythmic pattern at the end, building it, breaking it back down, and building it up again mainly by snare placement alone. The intro of "Confessional" certainly foreshadows the outro; drums, then bass, then guitars building the riff piece by piece. Once the riff is established, the rhythm section holds down the rhythm pattern while one guitar floats a solo melody on top, only to reconvene and lock back in. That's how this one ends. This was one of my personal favorites as it's drum heavy and drum driven. We played it often to great response.

# Confessional

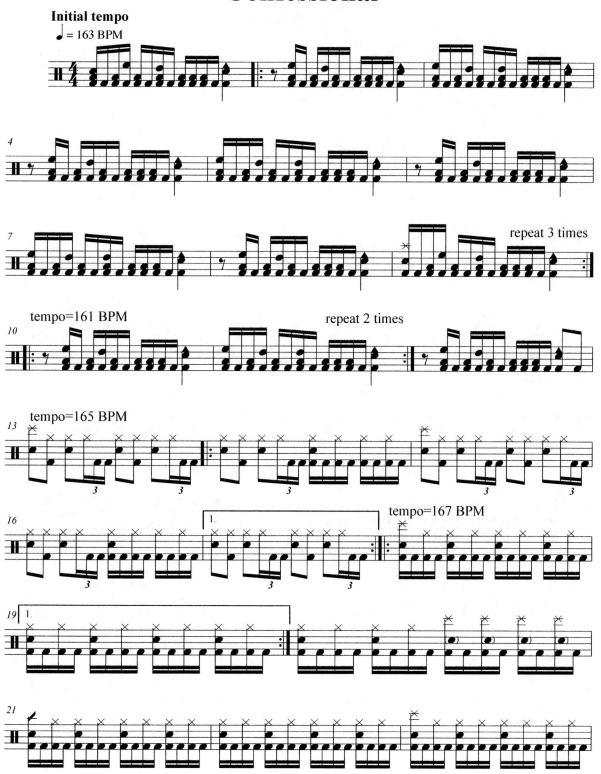

**Confessional**

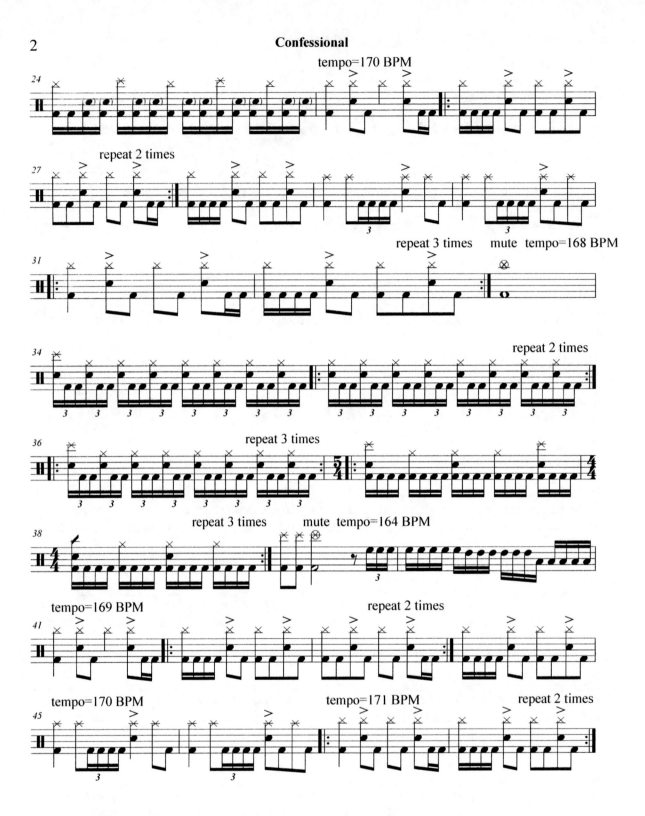

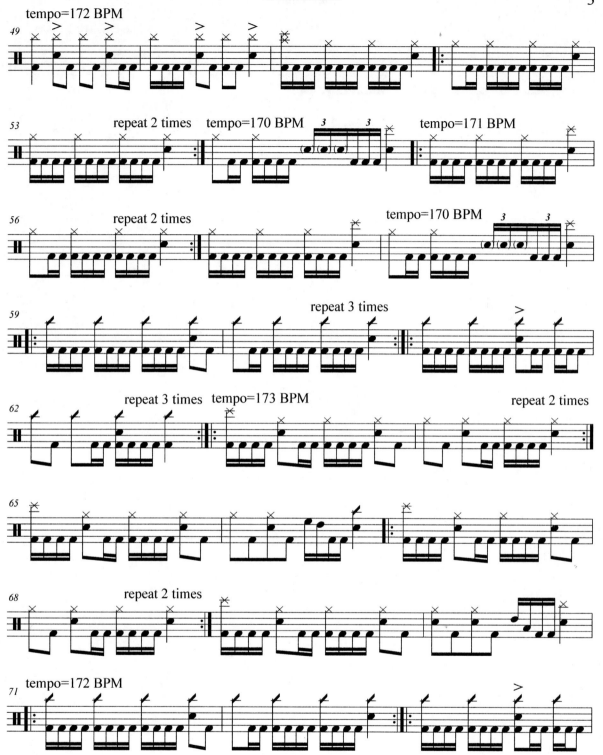

**Confessional**

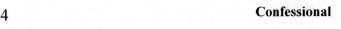

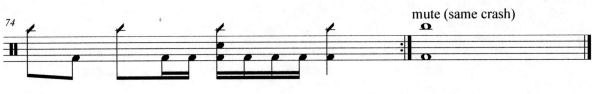

# O D.H.G.A.B.F.E.

Sludge. A few of the guys in the band were really into the slower, "Southern"-sounding New Orleans music scene at this time. This guitar line is a perfect example of what was happening there at the time, and it obviously made its way into Lamb of God. To me that style always seemed too slow. It was frustrating to play or listen to. I'd lose patience very quickly. I wanted the up-tempo bit, ASAP. The good news was, I found what I thought was an interesting kick pattern (with a triplet!) underneath it. It was fine with me as long as the next musical bit CRUSHED. When it first arrived, however, there was no next bit.

I have an affinity for triple feel. If you've made it this far in the book you know that—sorry. At the time though, I didn't even know what that meant. It was a natural tendency, not a routine or exercise from a book. I would often arrive before the guys and warm up with triplet feel kick drum runs at various speeds. Guys would come in one by one and practice would ensue. Several times, if one guy was earlier than the rest they'd riff or lock in on top of my warm ups and I believe that is where the idea for the next bit, the verse, originally came from.

Chorus next. Same kick pattern, different snare pattern and tom accents following the guitar riff. Drop back into the verse, this time kicks first. This verse is half the length of the first and we move to a stop/start bridge that takes the song to what I can only describe as "the middle." It's not really another verse, breakdown, or a solo. It's just, "the middle." I could say that better—it was the musical part of the song necessary to properly separate the two choruses, but honestly, that's pretty heavy BS. We had a riff and we made it fit.

I recorded this whole song too fast.[13] We knew it right away but didn't have time to do it again. It was probably me overcompensating for the droning intro and outro, but it came back to bite me in the ass here in "the middle." There's a kick run of six really quick 16ths that repeat towards the end of each rep of the beat, then flip to the front of the beat before the kicks go to a steady 16ths pattern when the guitars tighten up. If I had been using triggers it would have been fine as you can hear that I get all six in, but because I had ramped up the tempo so much, I had no power at that speed and the runs are not as audible as I'd like.

---

[13] Actually, I recorded the entire album faster than we had ever rehearsed it. I had always wanted it faster, but the guys would pull me back, not a ton, but maybe 5–10 bpm. In the studio, the recording process begins with the drums. Once the drums are on tape, we add guitars, bass and vocals, typically in that order. In future recordings, we defined a click track in pre-production so that everything stayed the same speed in the studio. We didn't do that with *New American Gospel.* I was able to set the pace where I wanted it. I still remember getting the stink-eye once or twice from the guys in the control room while I was tracking.

Yes, I'm picky. So are you, we're drummers. Deal with it.

"The middle" dumps right into a final (2nd chorus), which is followed by an outro that matches the intro with it extending an additional four repeats. I always thought the length of Randy's scream here was pretty impressive, not that it's a great life skill or anything.

# O.D.H.G.A.B.F.E.

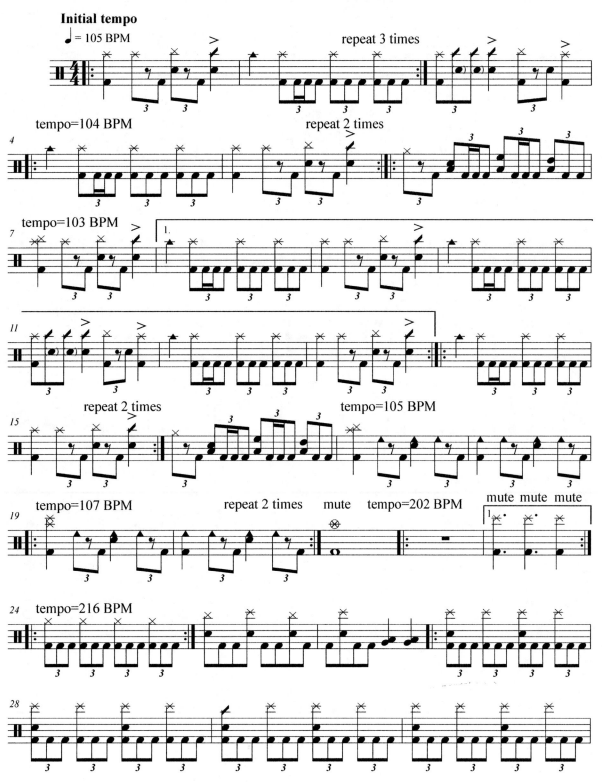

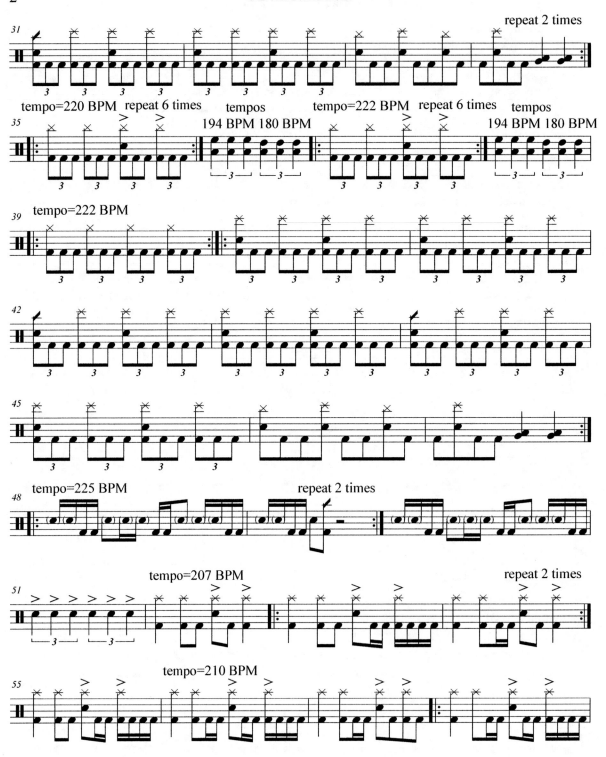

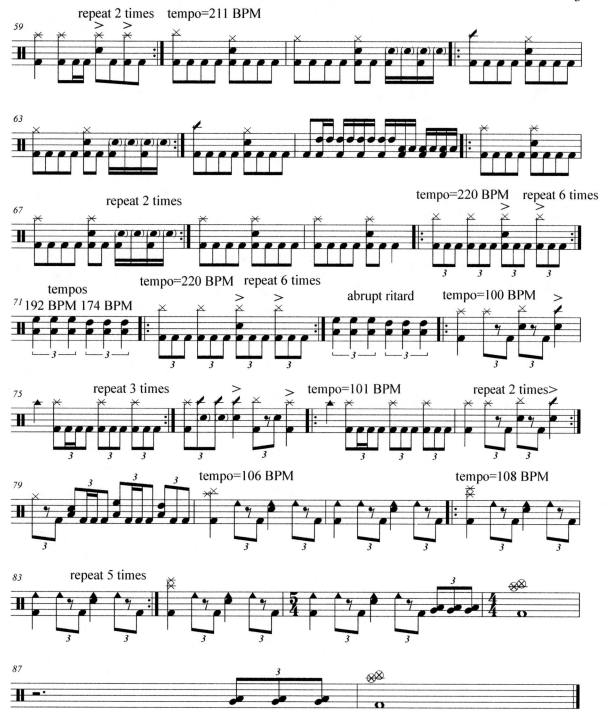

# NIPPON

*New American Gospel* was released on September 26, 2000. We were DIY touring everywhere we could at the time. We soon found a booking agent that got us on tours, but it took a while. By now we had been a band for six years. The label came back to us around the time of release and asked if we could go back in and record an extra track for a release in Japan.[14] We didn't have any more material and the budget was gone. We were in live show mode, not recording mode. The label explained the importance, offered us a whopping $250, and dangled the carrot of the possibility of a future Japanese tour if we did. Good enough for us … except, they wanted it in one week.

We holed up and put this little gem together. We recorded it in one day at the GWAR rehearsal space with their soundman. This helped further build a relationship with those guys and probably helped us land the opening support slot on their tour (our first proper venue tour ever) shortly after. I think we were all thinking that since the album was done that this was going to end up being a bit of a throw away. We didn't write under that assumption, we wanted the song to be as good as anything else we had done, but since it wasn't going to be released in the US, we had no plans to add it to the set list at concerts. If the Japanese tour were to happen, of course we'd revisit. That didn't happen until six years later and this song was long forgotten in that time—except in Japan. When we finally got there, THIS was the song everyone requested. We had no time at all to try and rehearse and get it up to speed (it was a festival setting—no sound check). We may have sound checked or warmed up with it once or twice back in the day, but we never actually played this song to an audience. Shame. I'd venture to guess that most fans of the band don't even know this song exists.

I personally feel the song is amazing. Certainly one of my finest moments with kick drum speed,[15] and the riffs are pretty tough. Plus, it starts with a drum intro, like EVERY great song in the history of history. I'd put this next to any of the tunes on the US version and say it holds it's own.

I had a good time working with Travis to transcribe "Nippon." It had been so long since I'd even heard the song. When we opened it up, I had to sit behind my kit and try to remember almost the entire tune as we

---

[14] Despite what you might think, all of the Japanese bonus tracks you see and hear of are not because we all love Japan so much that we want to give them some extra love. It's also not the case that you tack on the runt of the litter of tunes and call it a Japanese bonus track so no one can criticize it as hard as the others. The deal here is that if you don't give the Japanese market an extra tune, they won't release your record in their country. That simple. I've been given many reasons why, but the one that makes the most sense is that the market is small and if kids want it, they will pay to import the US version. However, if you want it physically on shelves in stores and some kind of marketing for it in hopes of growing your share in the market, pony up the extra tune.

[15] I'm pretty sure the kick run starting at 3:36 is now, officially, out of my league. I'm getting too old for that sh*t.

wrote the tabs. It's not going to make an appearance to our set list anytime soon, but it reminds me how intense we were at the time that we could just go whip this up—in a week.

Back in the day, man . . . we were immortal.

# Nippon

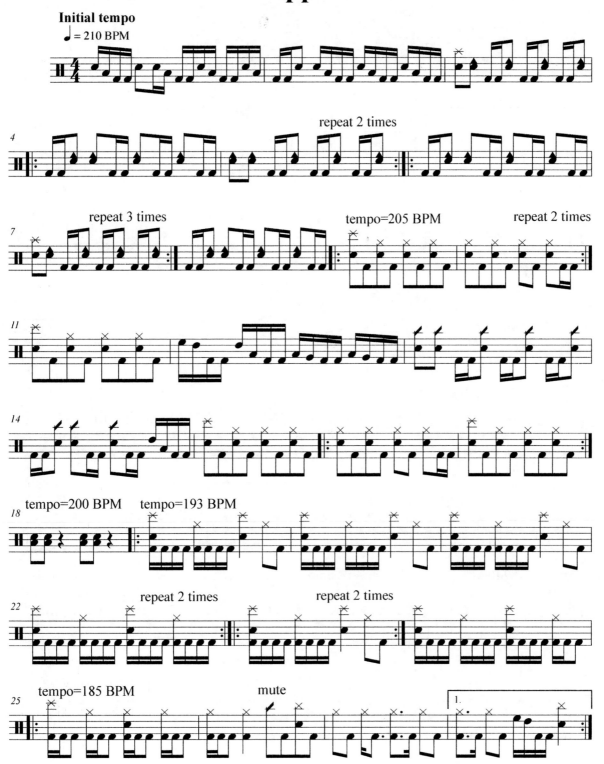

**Nippon**

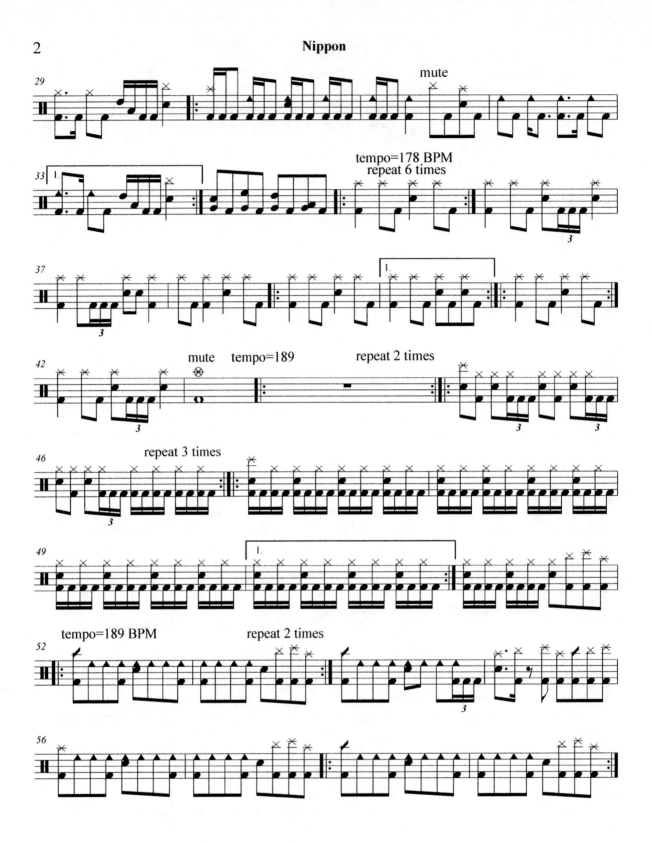

# Nippon

3

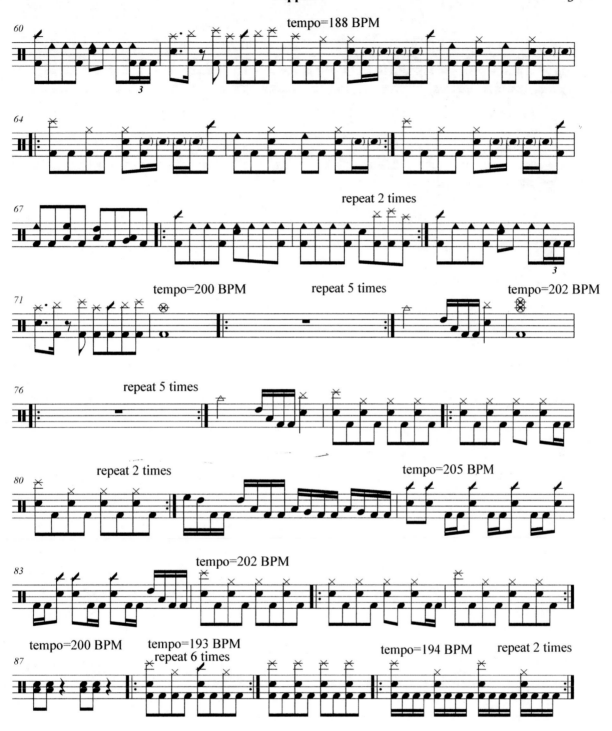

101

**Nippon**

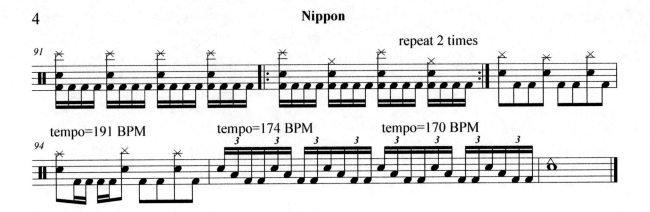

The End

For more information please visit:

www.Chris-Adler.com

www.lamb-of-god.com

www.TravisOrbin.com

www.k3n.com